David Bailey

David Bailey **Tears and Tears**

Steidl

Dedicated to Catherine Bailey

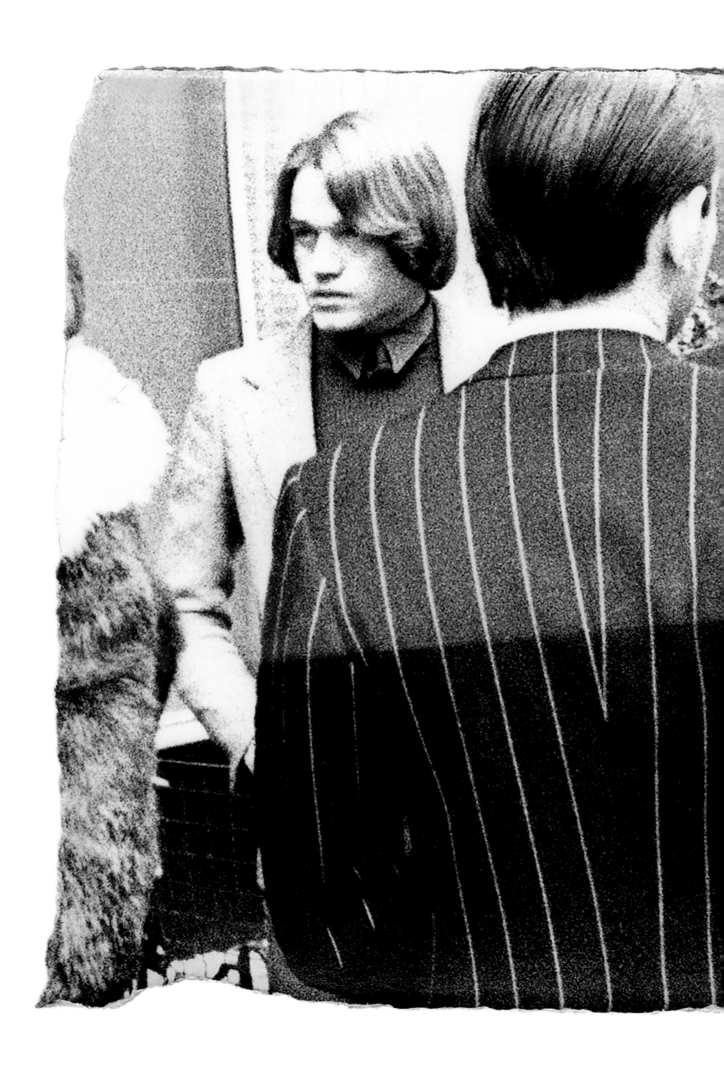

Andy Warhol *1972*

Archaeology Bailey

Dear Bailey,

visiting your studio and asking in my stubborn German way again and again if there is not something aside from what you are currently doing, what you are now working on and advancing, something other than the new, huge, colourful, digital prints, sometimes blurred and pixilated, sometimes very much cropped … I cannot even decide what is cropped and what is still there on these coloured seas, oceans, which are unrolled on the floor, this bare board and so important floor, their ends curling somewhat, still moving like baby waves lapping on the beach; other than these and the canvases you continuously work on, gluing scraps of paper onto them. Are they photographs, pictures, details, maybe fascinating pieces of photography and not so much pages torn from a book as details torn from a history, from an œuvre, from the artist's work, favourites selected and put forward? But put forward in essence, as concentrates, reduced to the main element, shedding all the excess of margin, elegance, common sense and agreement, simplified to the core, the mother of the picture, the seed. Therefore yes, these are intriguing and captivating.

Let's find out where these are grown, which tree they are picked from, which radical thought or possibly "not-thought", possible intuitive longing for a pre/post sin state of photography or art, which picture-creating force, which neglect of all long-taught and learned photographers' codex rules allowed these to be made and survive. My questions focus on these papers – now pictures – under the layers of paint, hidden there but surely also existing outside and in front of the paint, somewhere around us, possibly in a box waiting to be wetted and glued. Maybe, if I start opening boxes myself – but no, this is not allowed, one cannot use tools other than the practised Mark's hands or the master's hands roaming here and there, cannot uncover what is not meant to be uncovered, has to hover and wait to see what turns up, is allowed to ask, can probe and dig with words, patiently, and watch the drawer be opened, lower left, the box be retrieved, the lid lifted, and impatiently see the stack, the mound, mountain, snow-covered mountain, with the skiers' tracks zigzagging along its flanks, the stack of pictures face down in the box; watch them be lifted out, one by one, turned over to reveal their messages of man or woman or thing or time or place or journey to the past or faraway history, a kind of mankind's standstill, in Nagaland or New Guinea, or messages of holy saintly white faces with black marks from India, or a famous person, his music turned on with the picture, in my head only, or the movie running fast forward-backward, faces blitzing simultaneously as it runs, or glimpses of Bailey's biography…

And finally in the middle of this avalanche of pictures the reflection of him/you in the window next to the girl, taking me back to the uncharted where I had never been, to where I can be now as this history is being created for me and us as we sift and sift and discover the hidden treasure of the torn pictures, the atlas of Bailey's work, not discarded but waiting to be carefully excavated and presented to the world.

Daniel Blau

Tears and Tears

The original title of the book was just *Tears,*
no sense there.

Tears and Tears, the first book with two words
the same meaning two completely different things.

The tears of the torn print,
or the torn print in tears because it's torn.

And I'm the dyslexic…

<div align="right">D.B.</div>

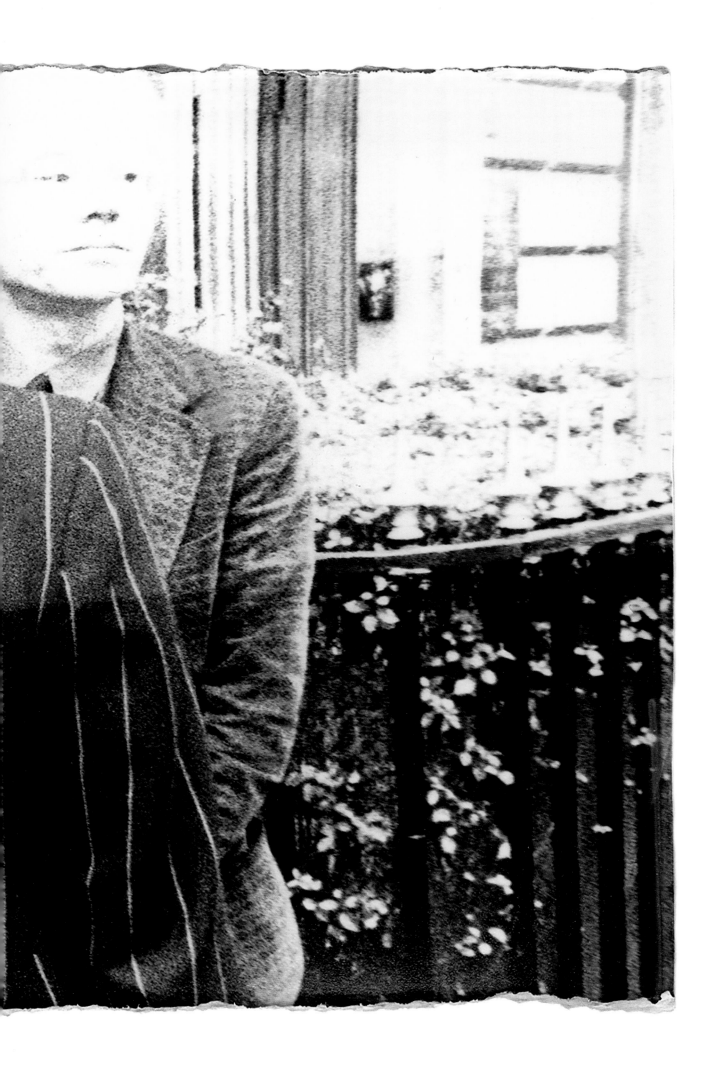

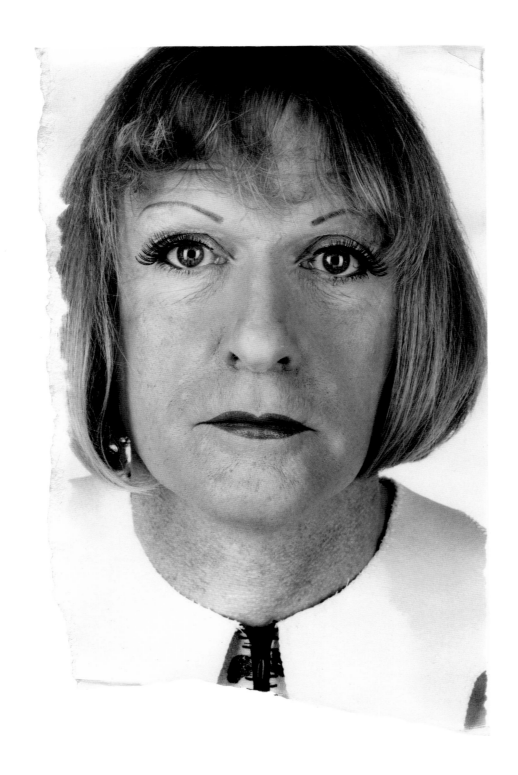

Grayson Perry *2012*

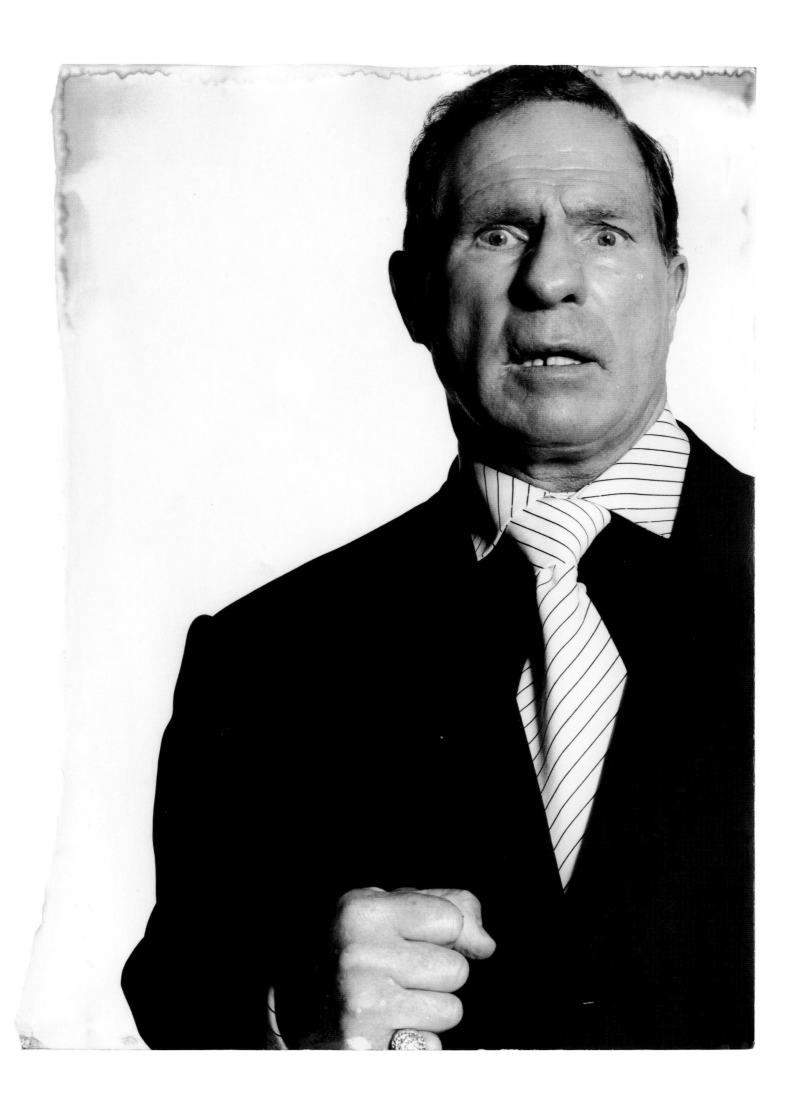

Roy Shaw *2002*

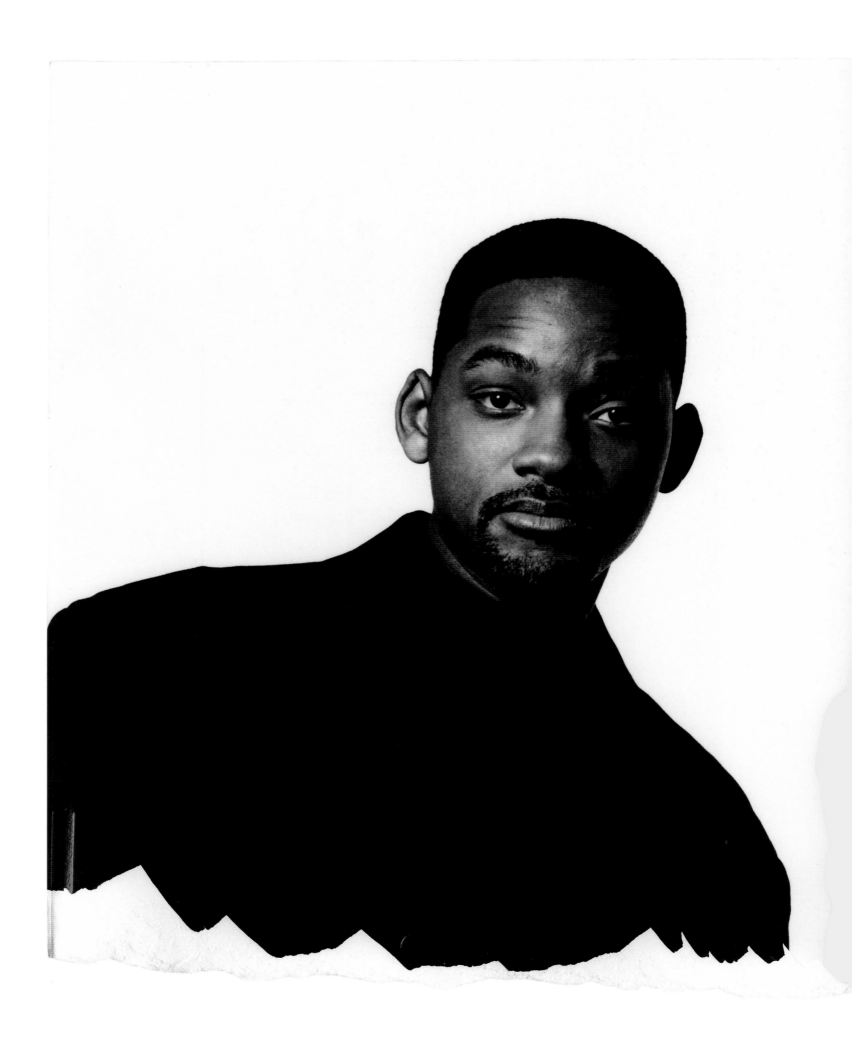

Will Smith and Tommy Lee Jones *1997*

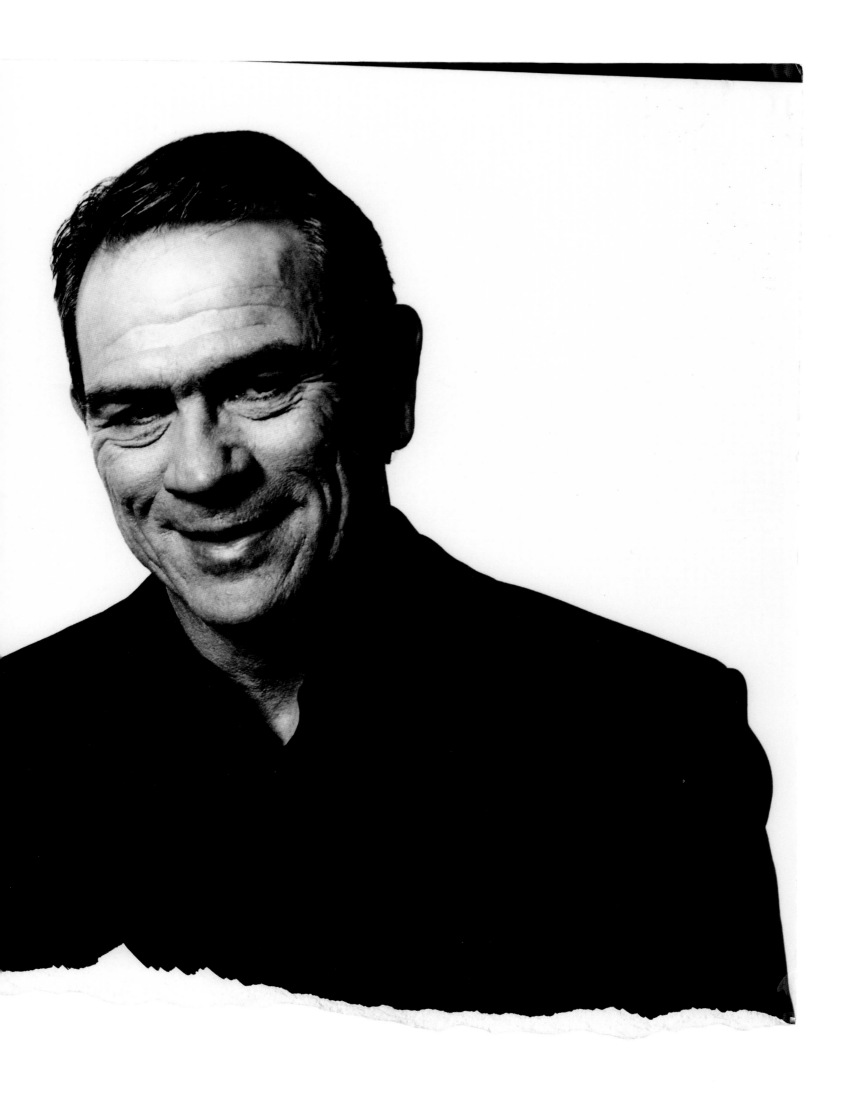

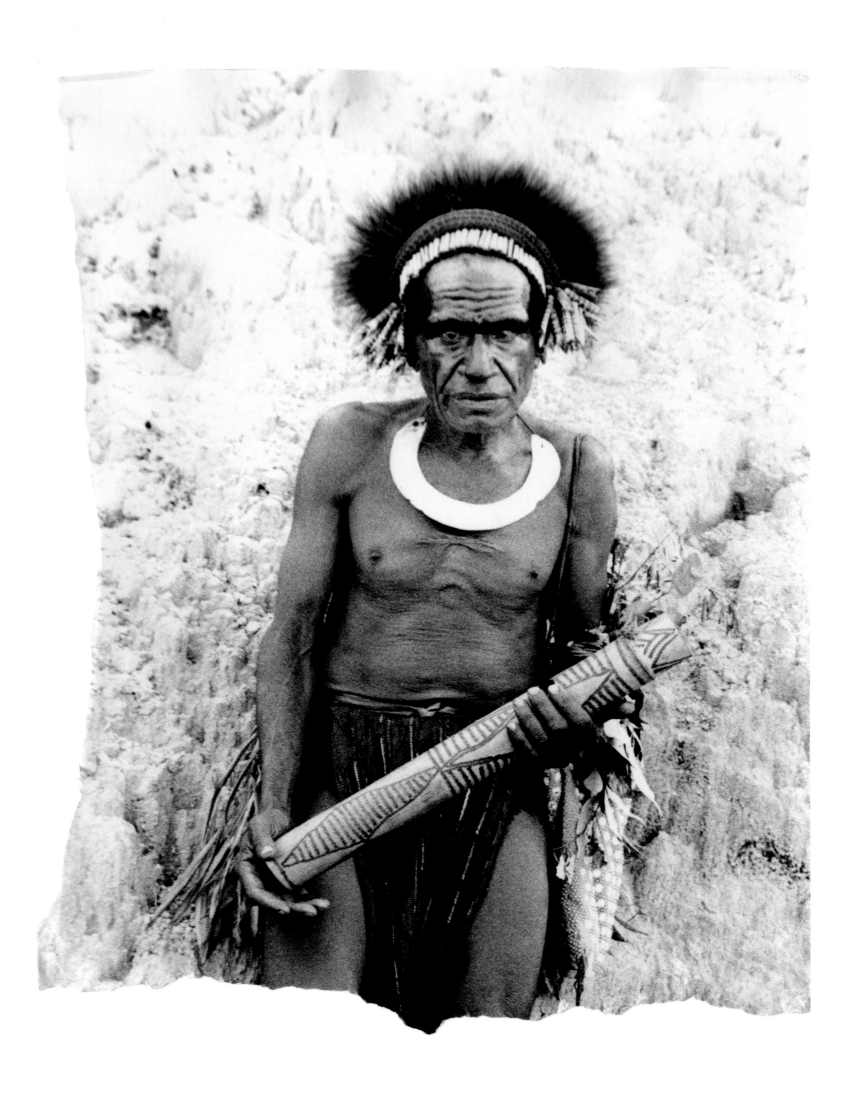

Papua New Guinea *1974*

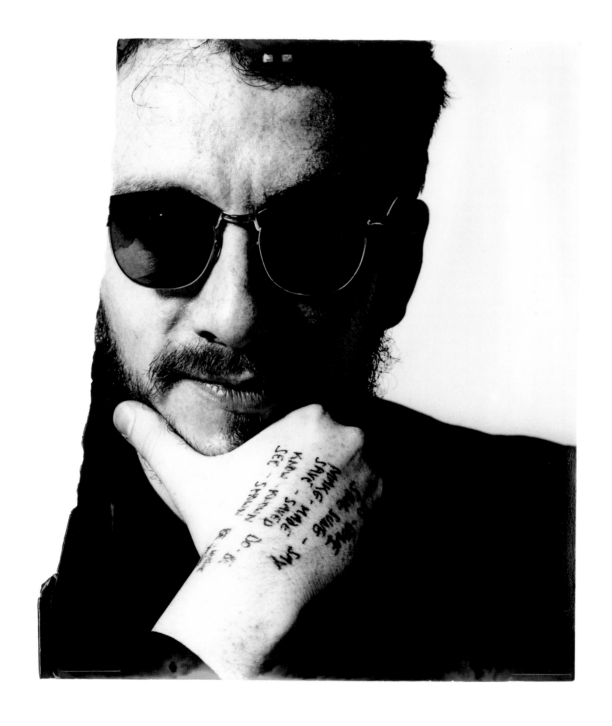

Elvis Costello *1985*

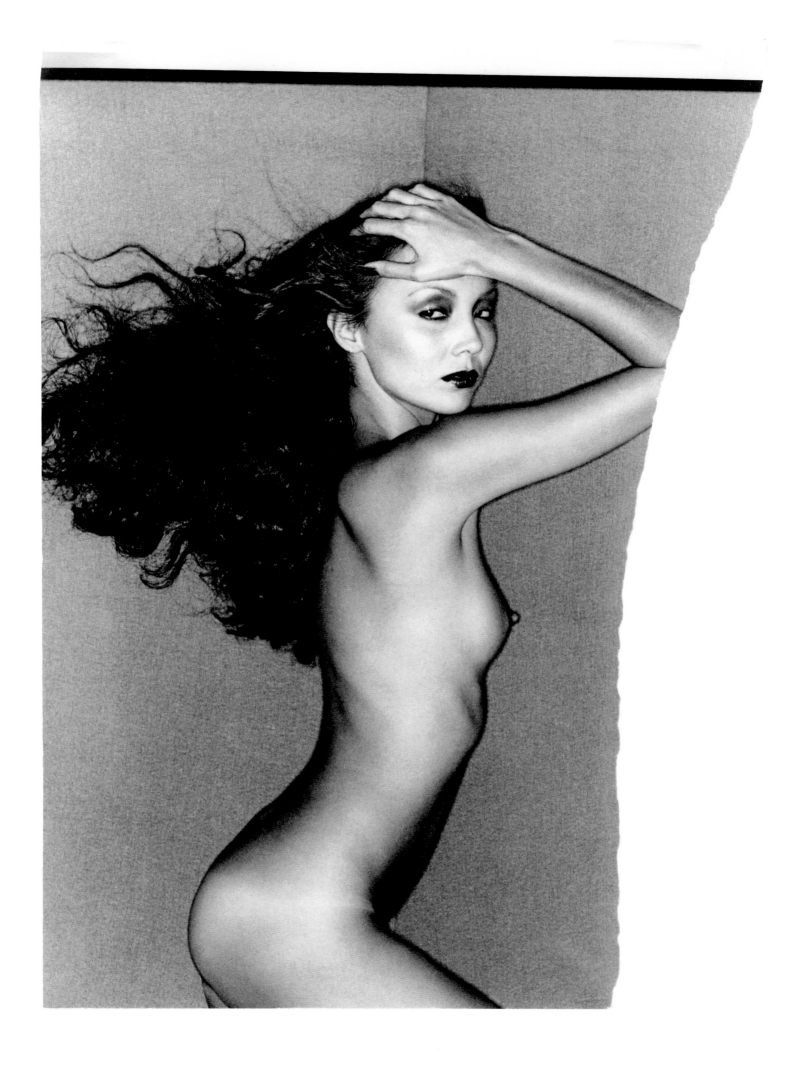

Marie Helvin *1976*

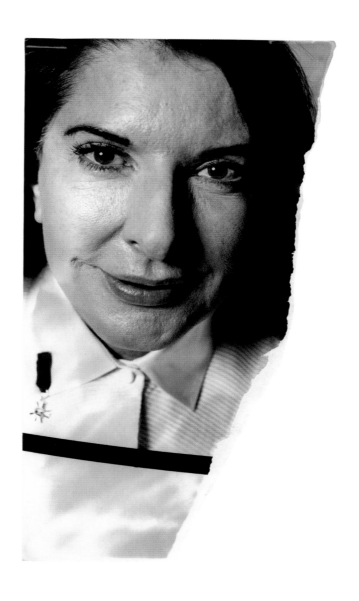

Marina Abramović *2014*

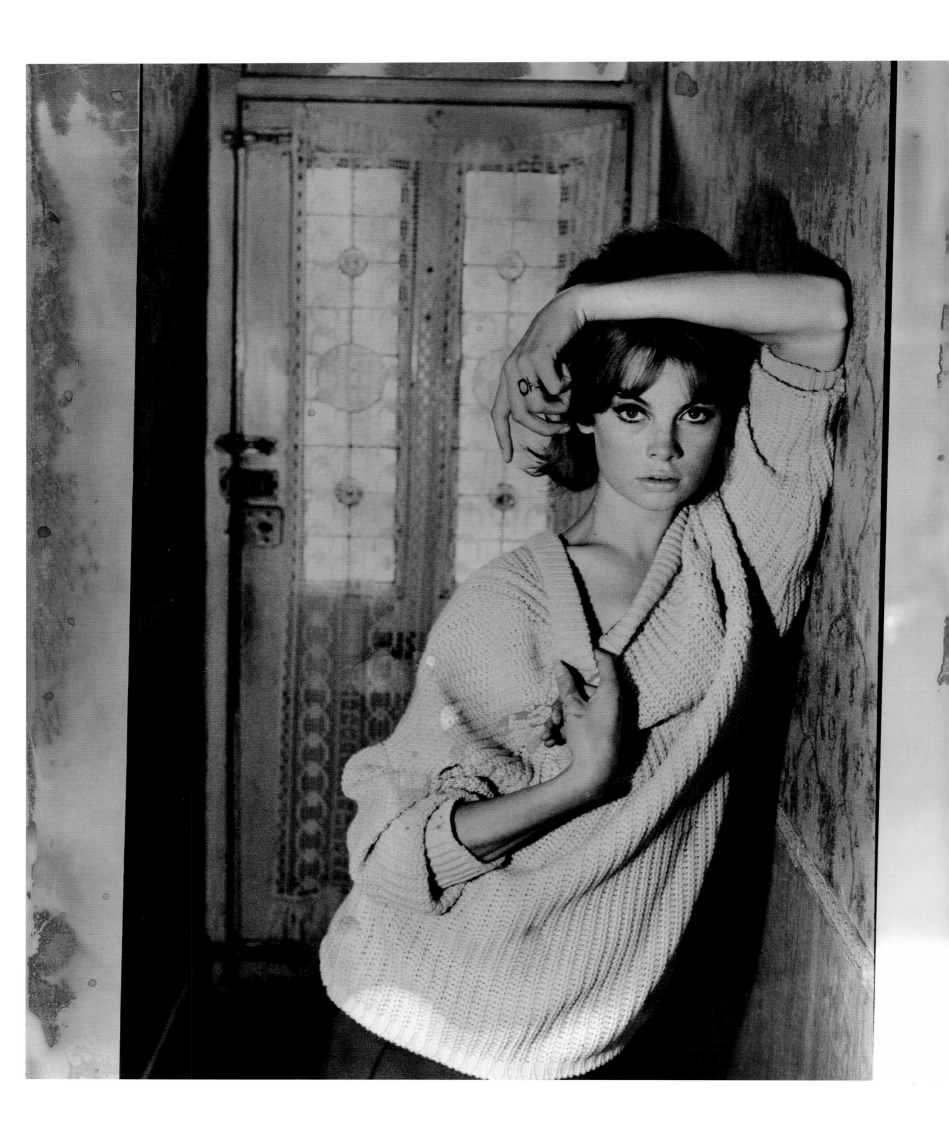

Jean Shrimpton *1961*

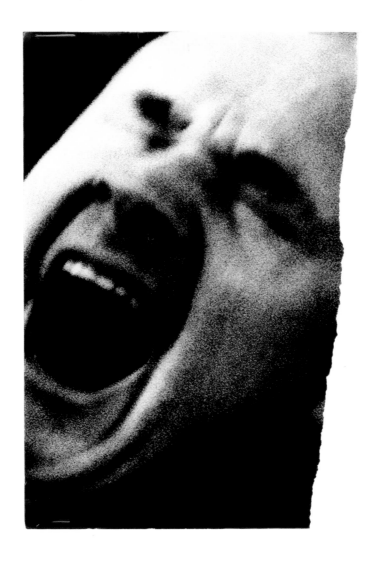

Damien Hirst *2013*

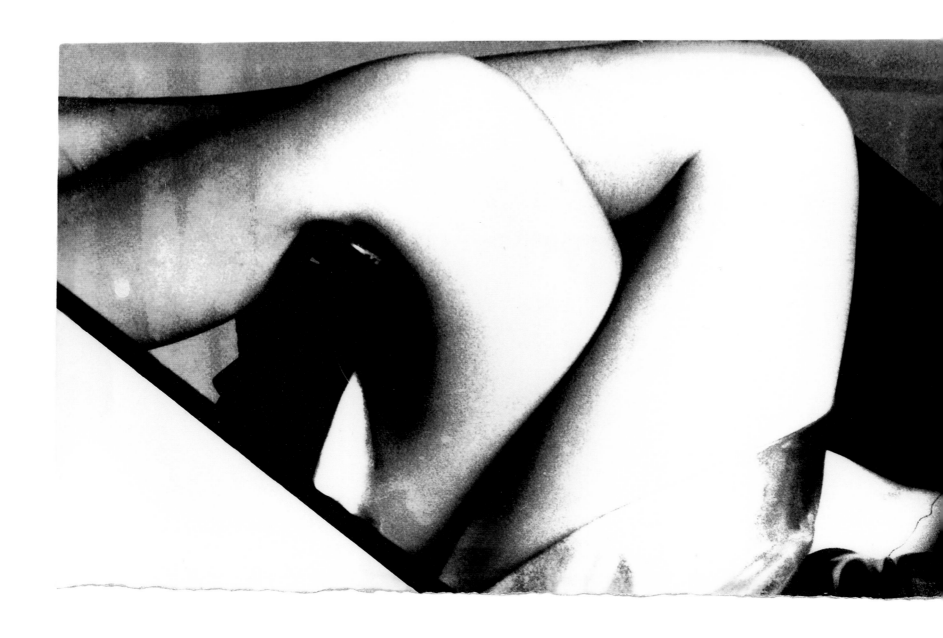

Candy Darling *1972*

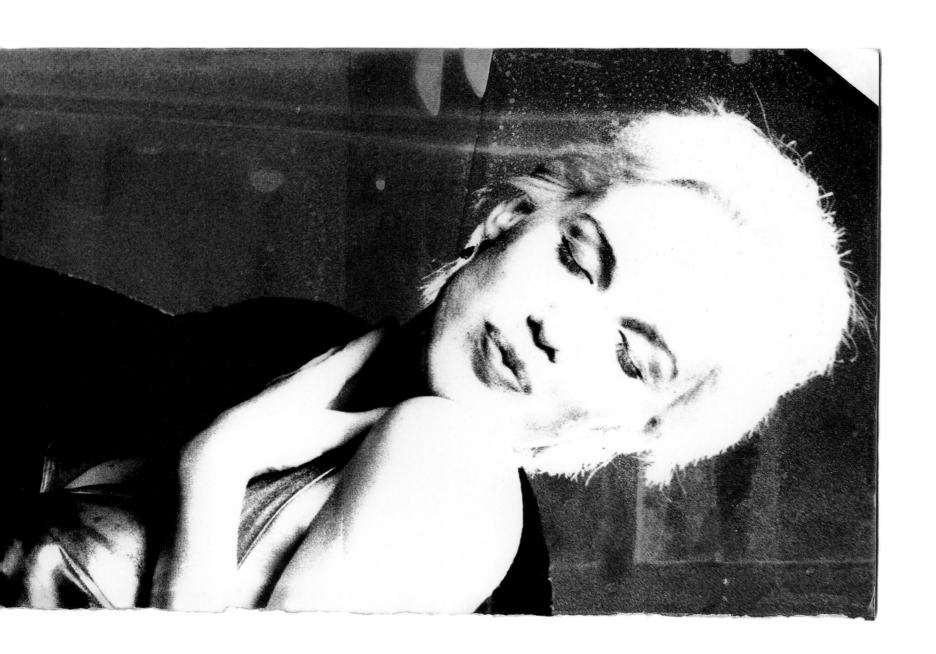

Catherine Bailey *2013*

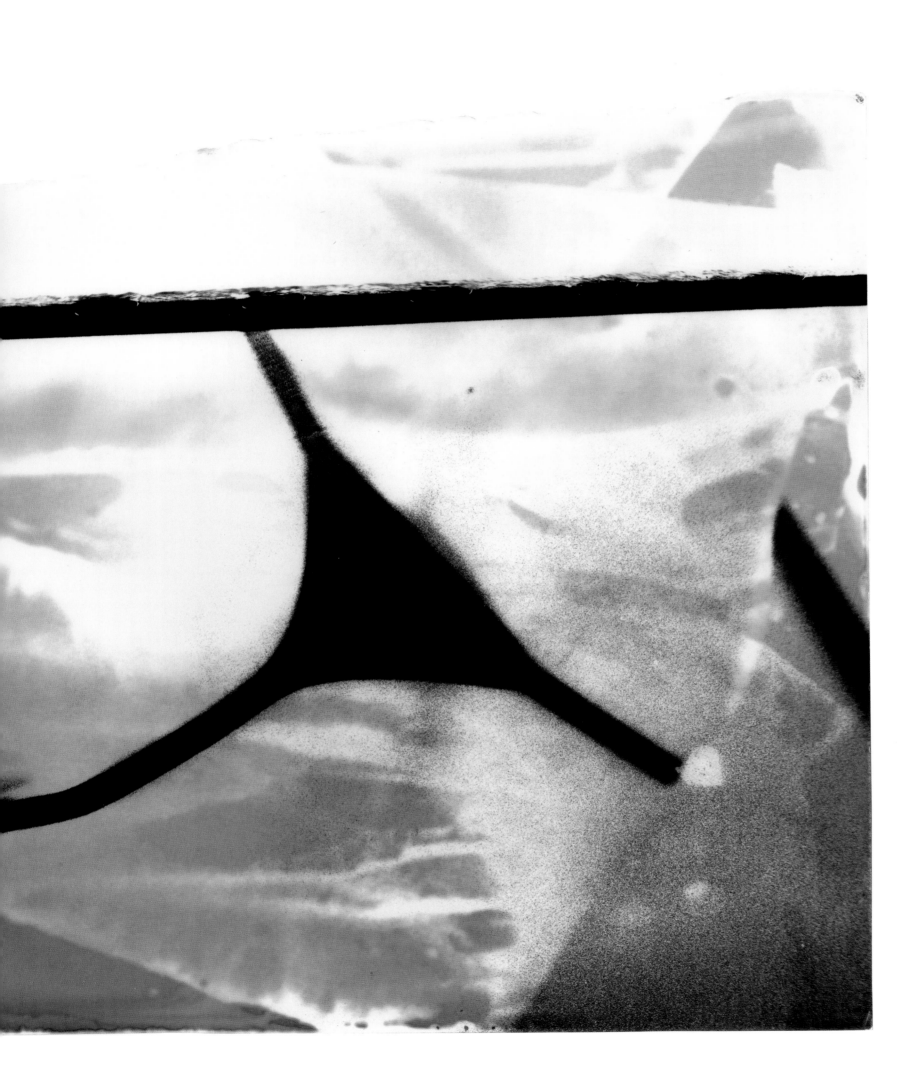

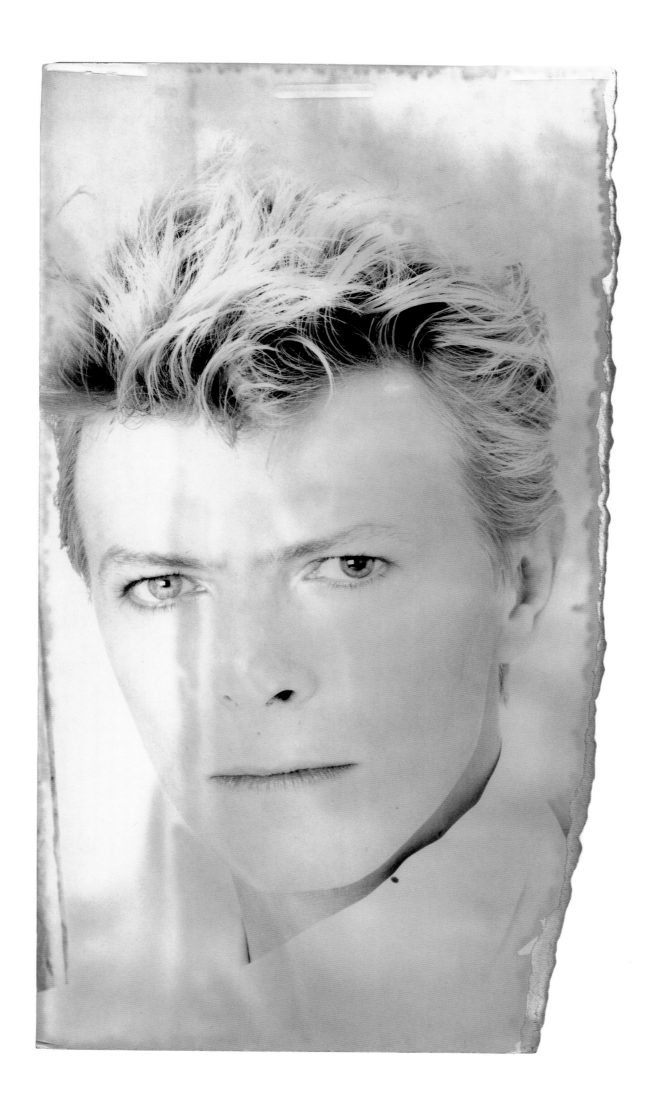

David Bowie *1983*

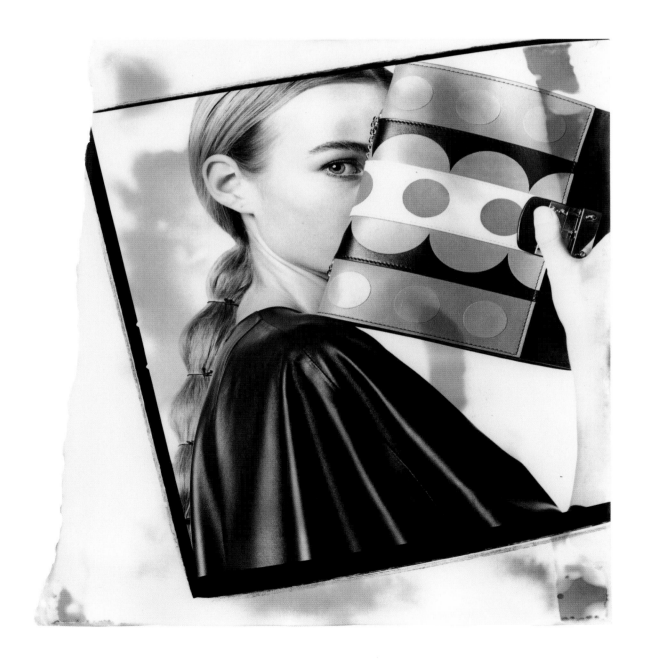

Valentino *2014*

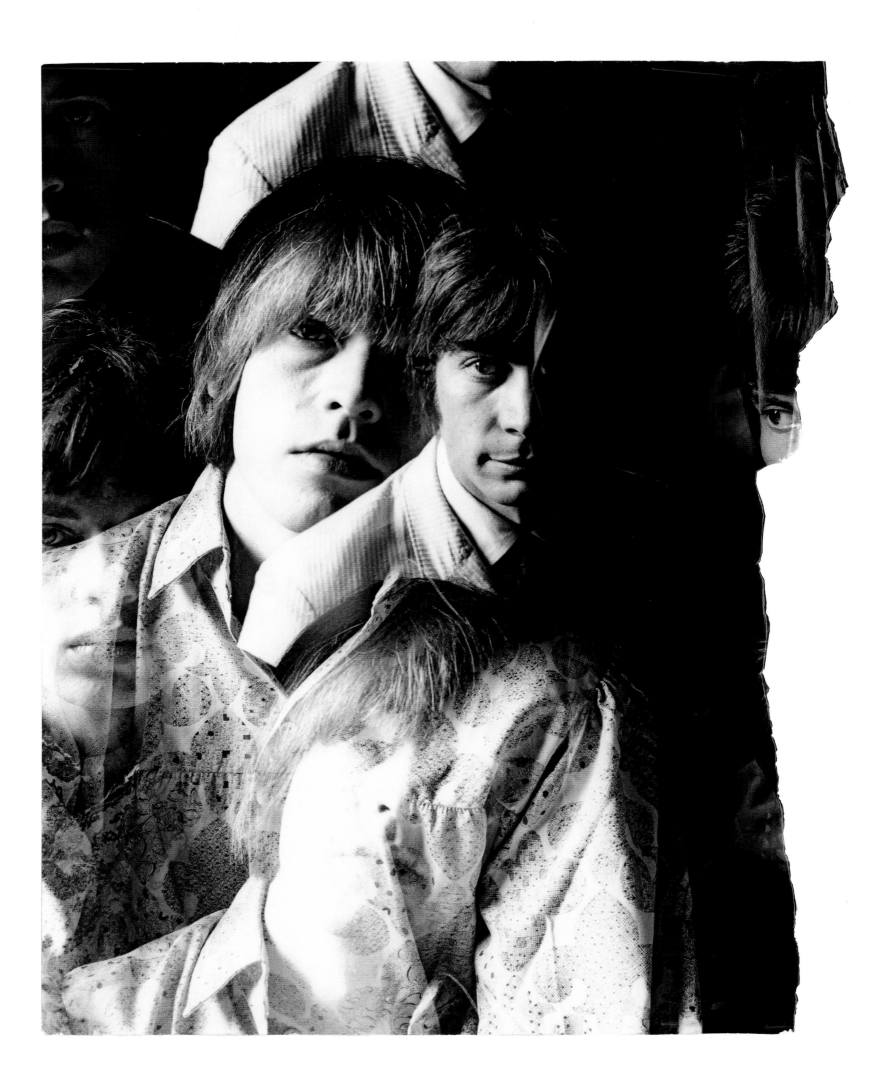

The Rolling Stones *1966*

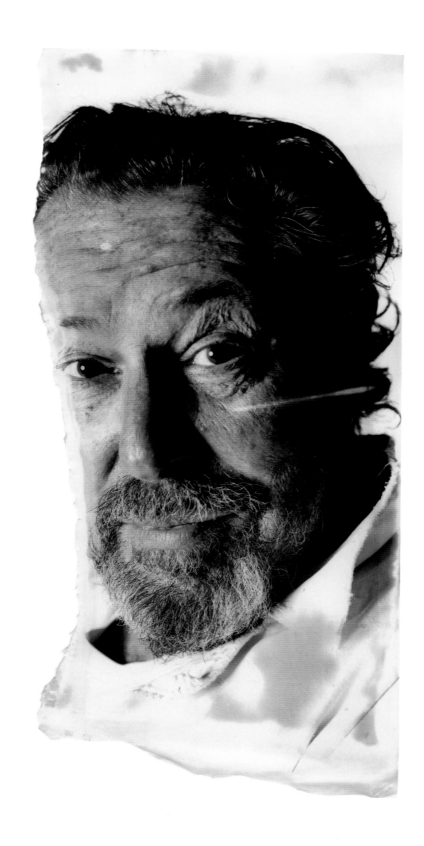

Julian Schnabel *2014*

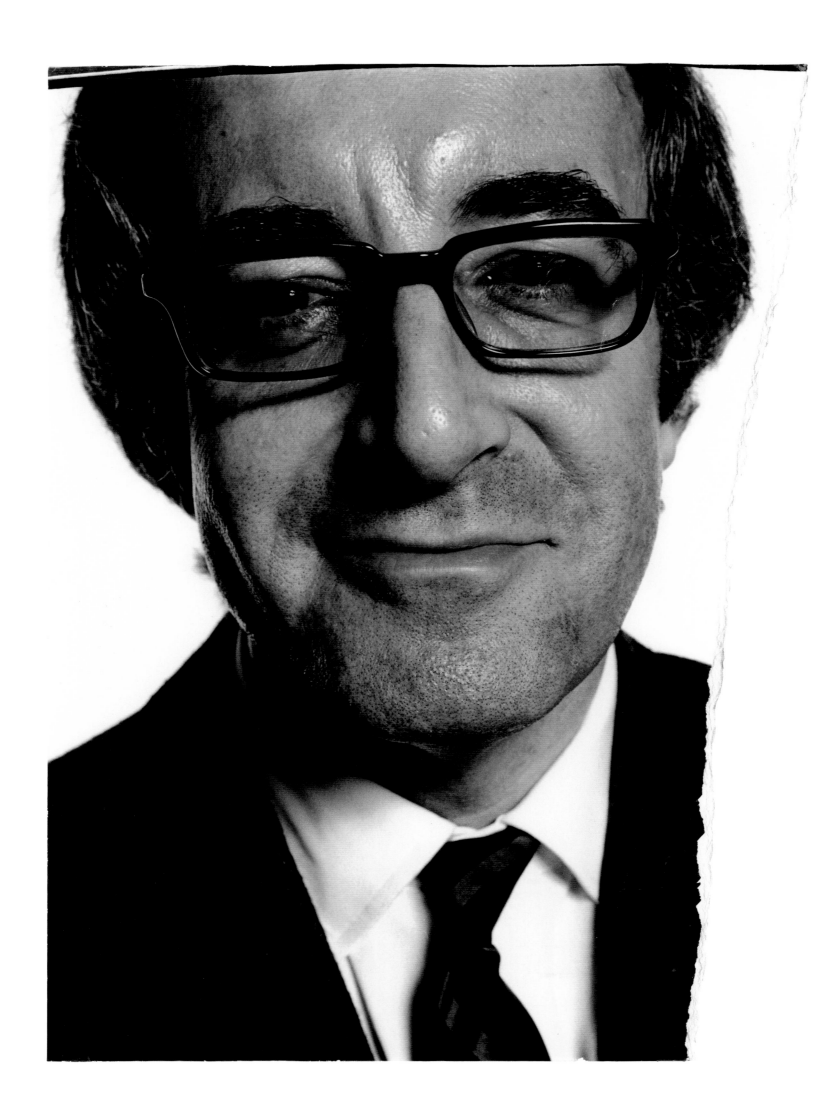

Peter Sellers *1968*

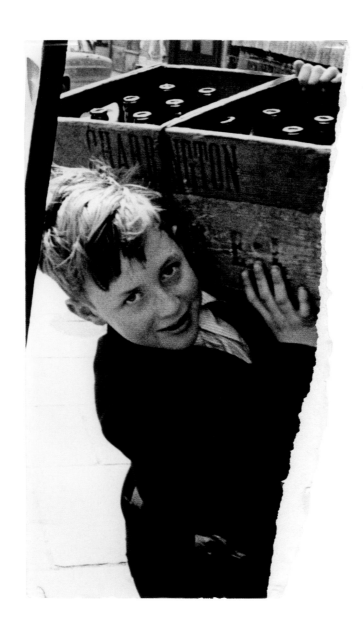

East End *1965*

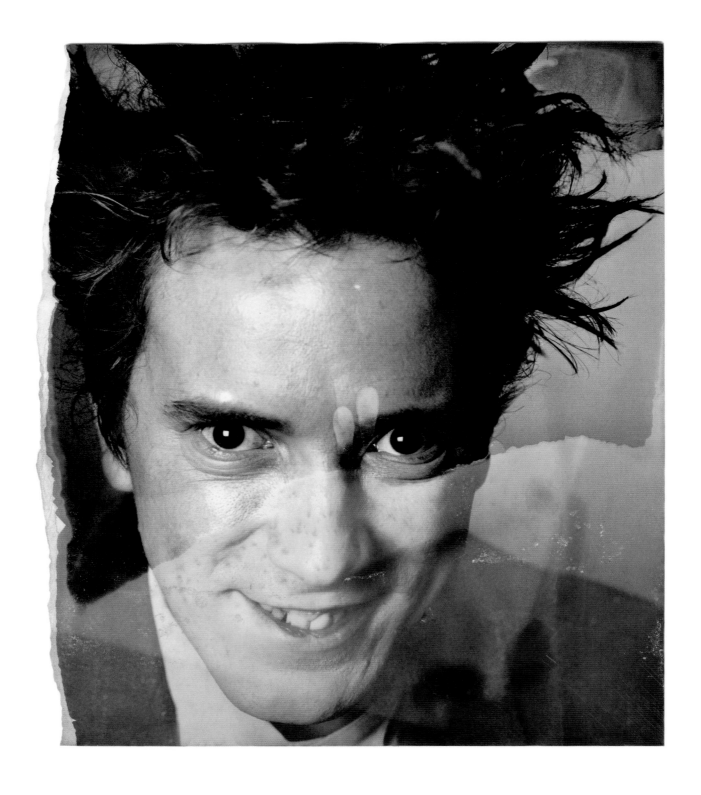

John Lydon *1986*

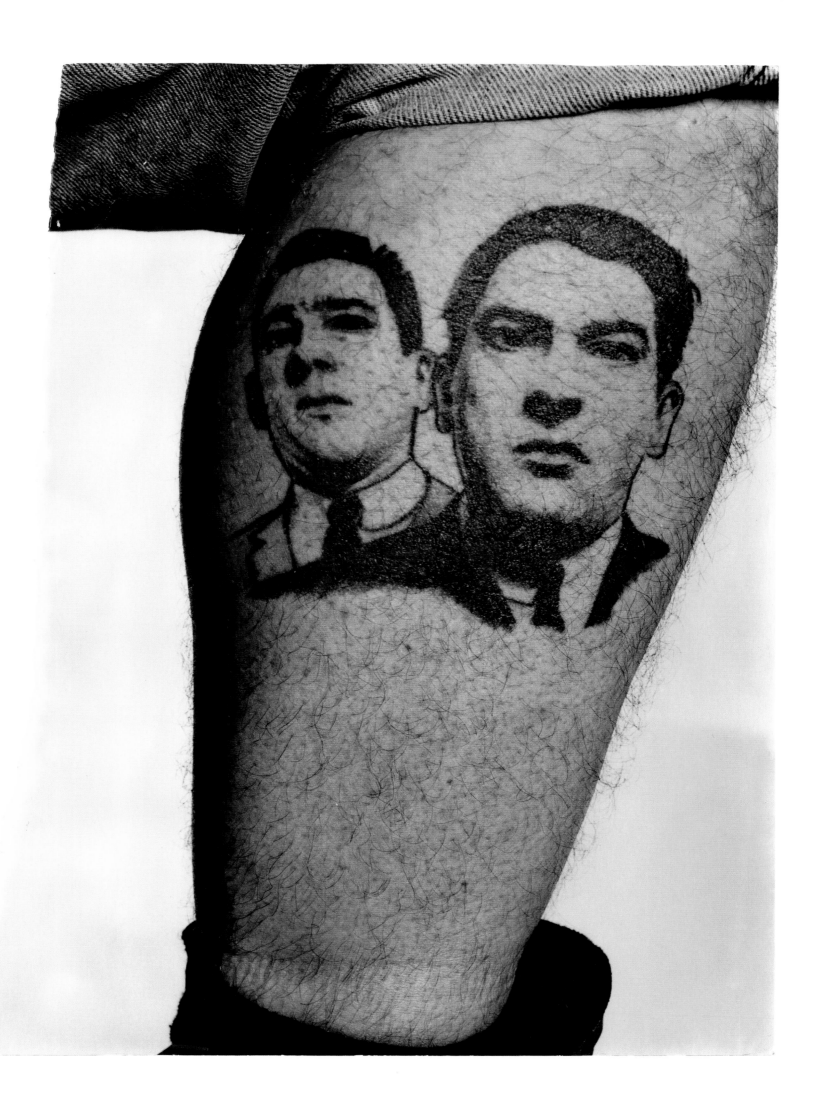

Bernie Davis *2002*

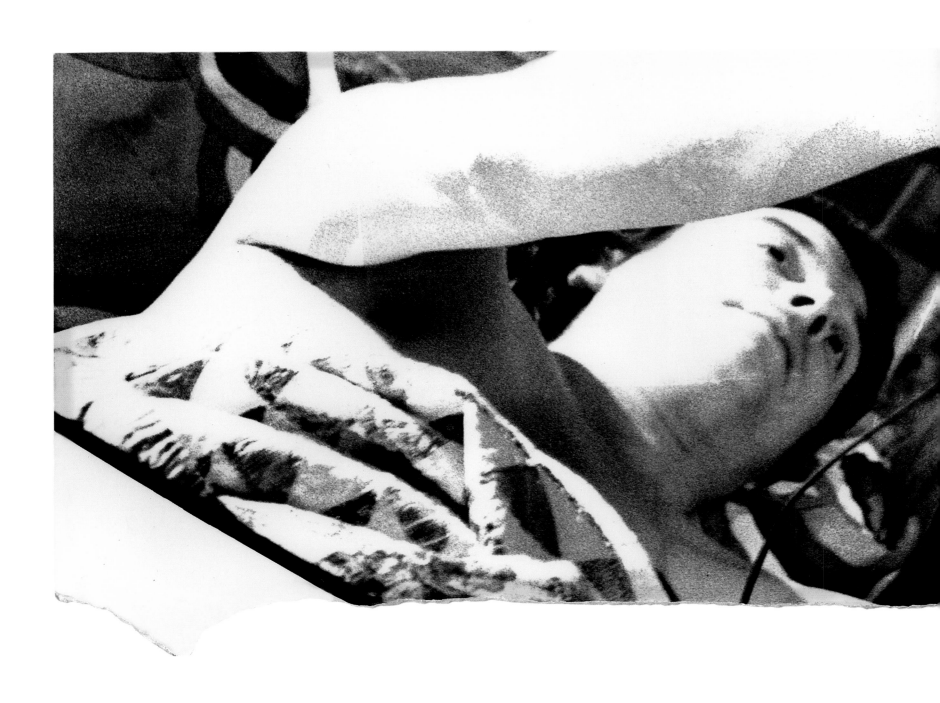

Bailey and Andy Warhol *1972*

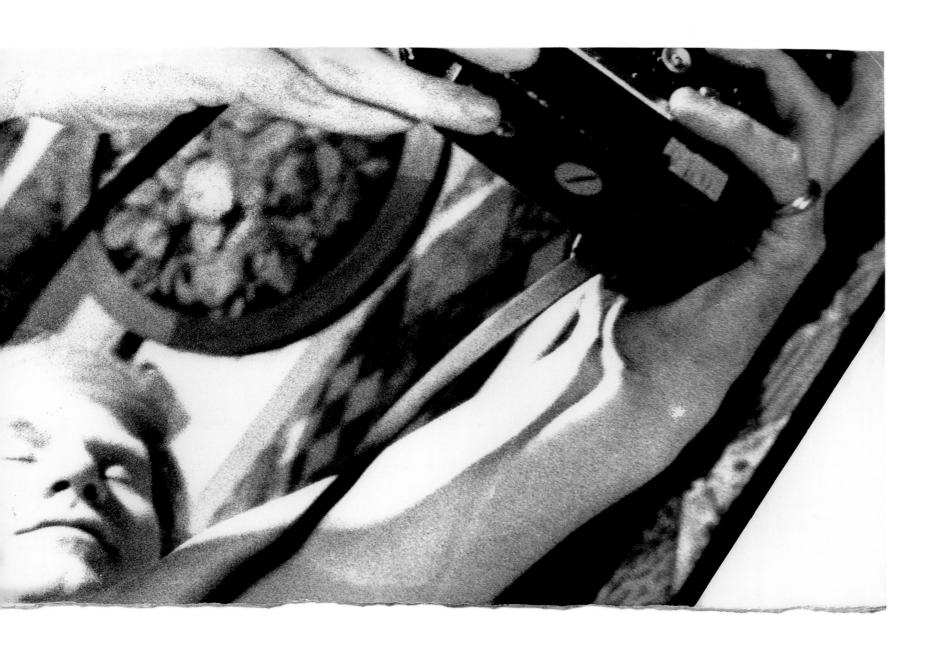

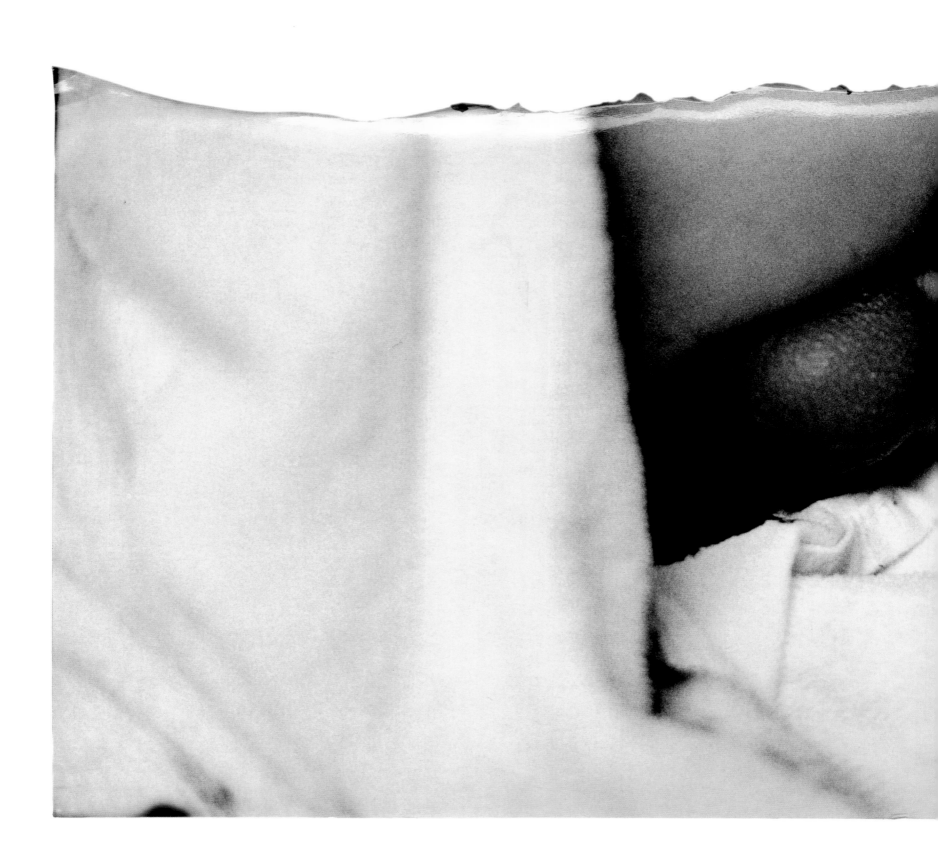

Fenton Bailey *1987*

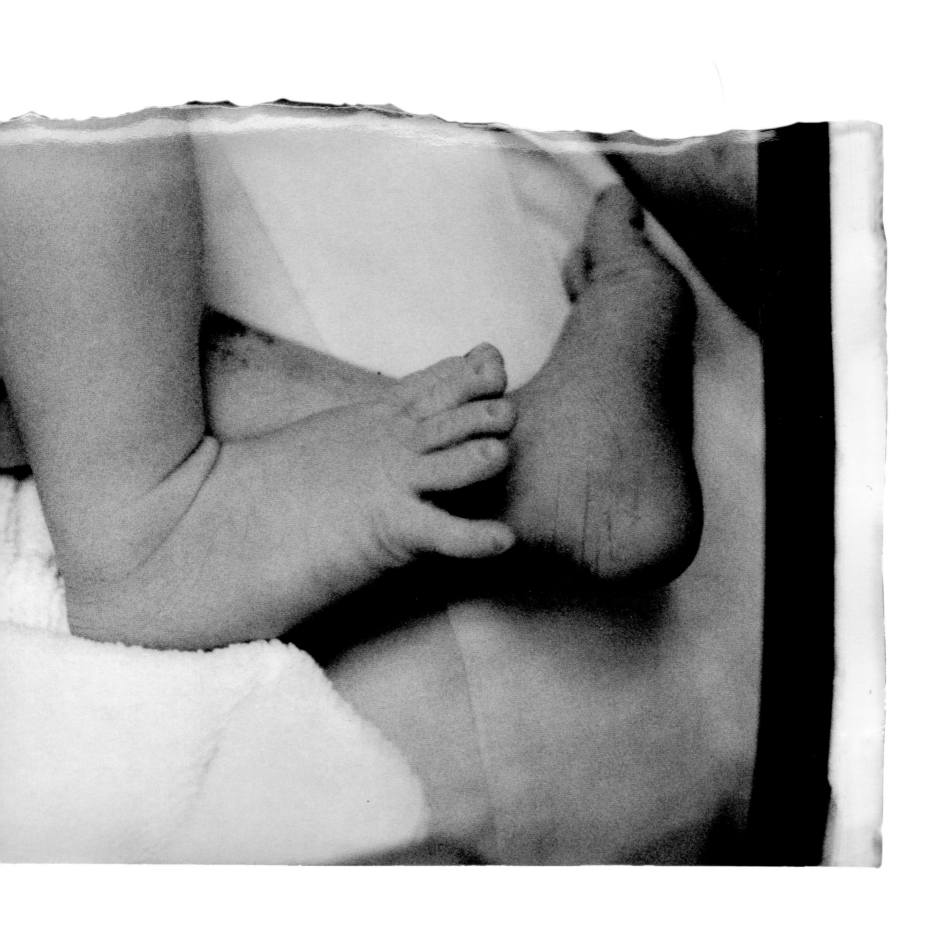

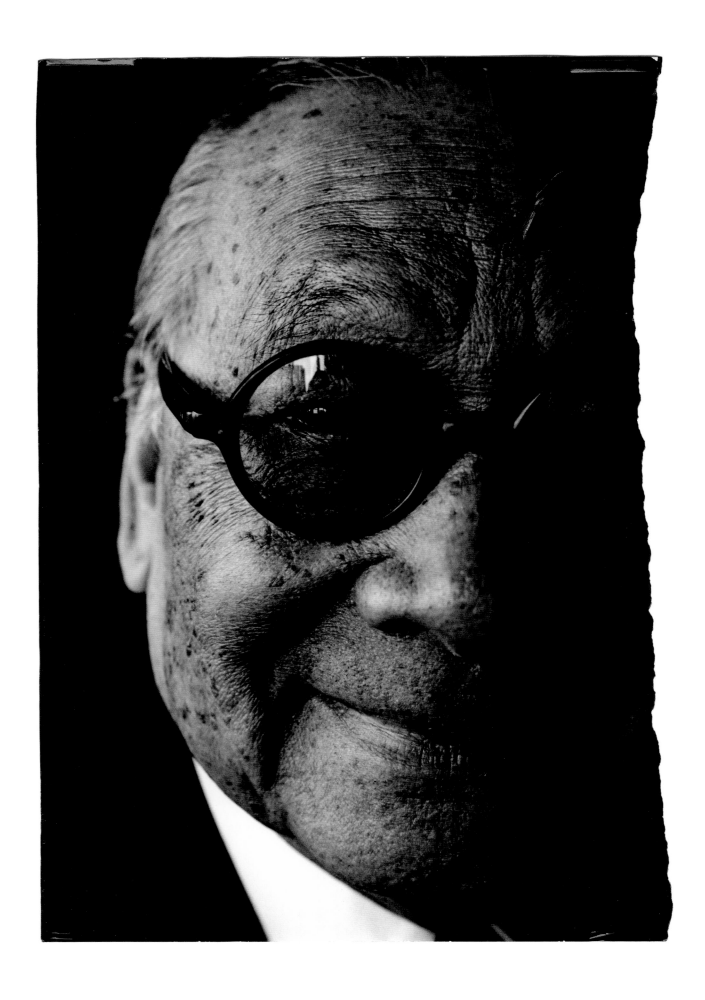

I. M. Pei *2000*

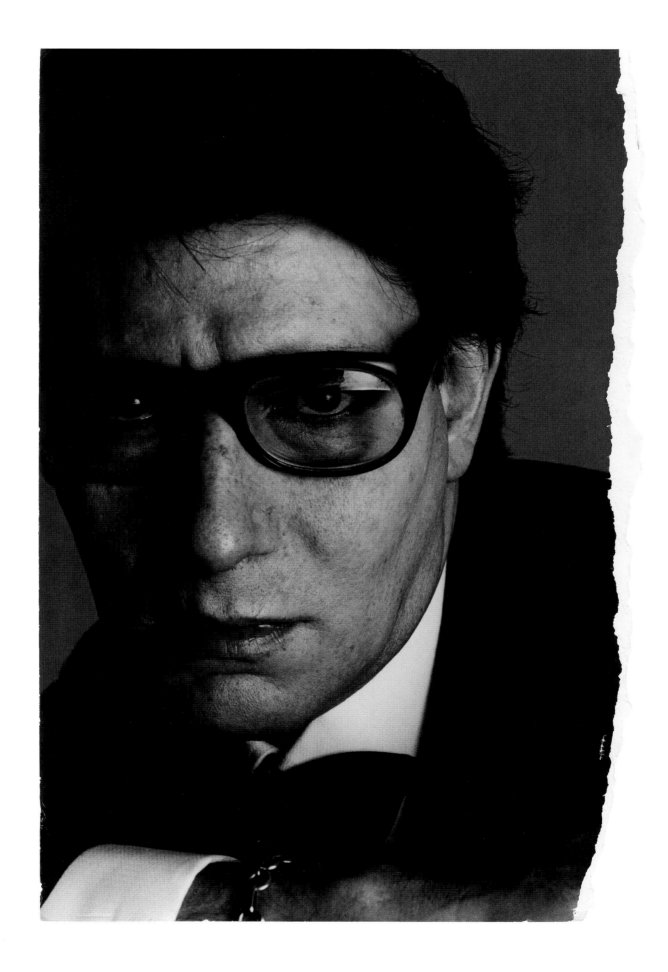

Yves Saint Laurent *1983*

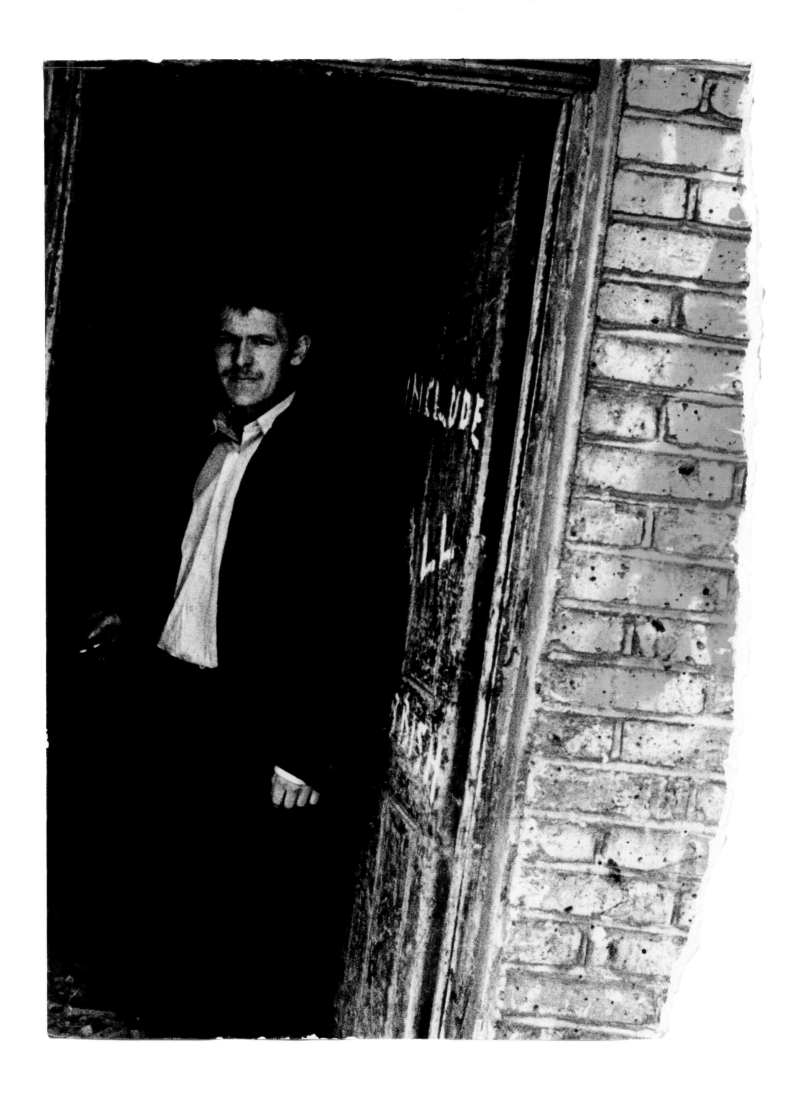

East End *1961*

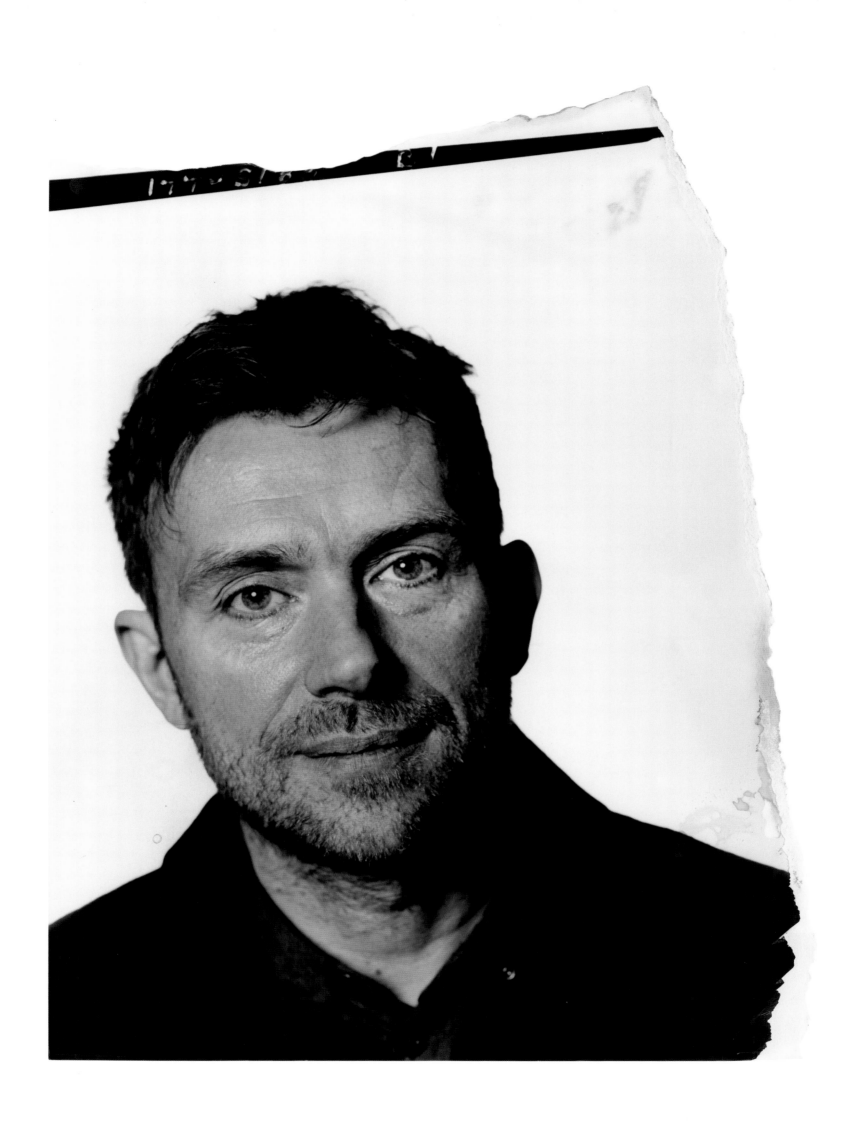

Damon Albarn *2014*

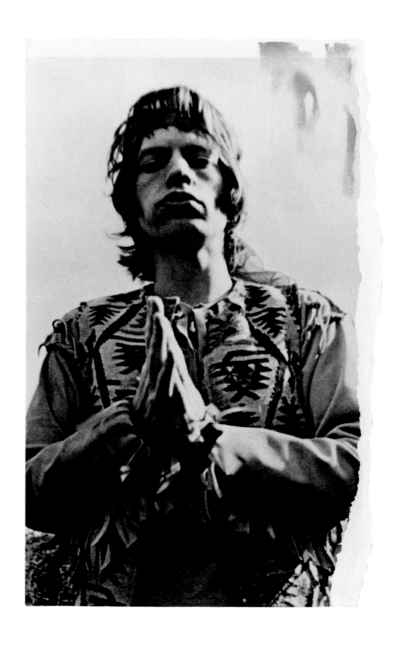

Mick Jagger *1968*

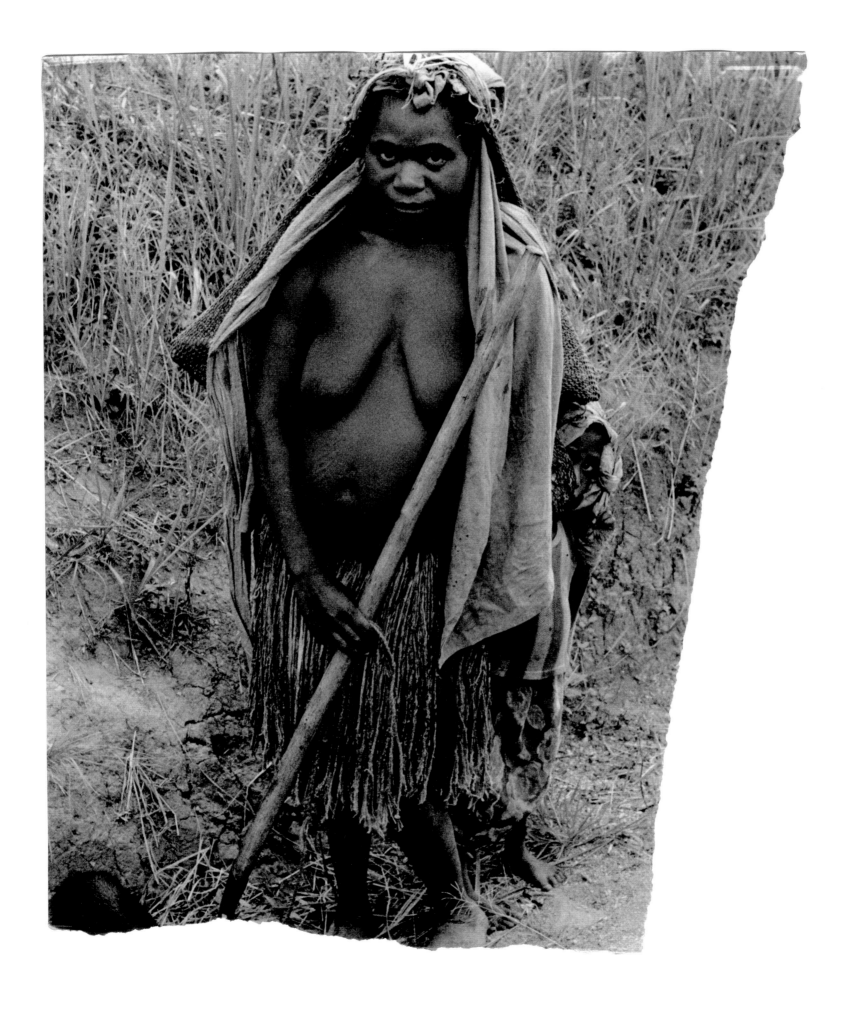

Papua New Guinea *1974*

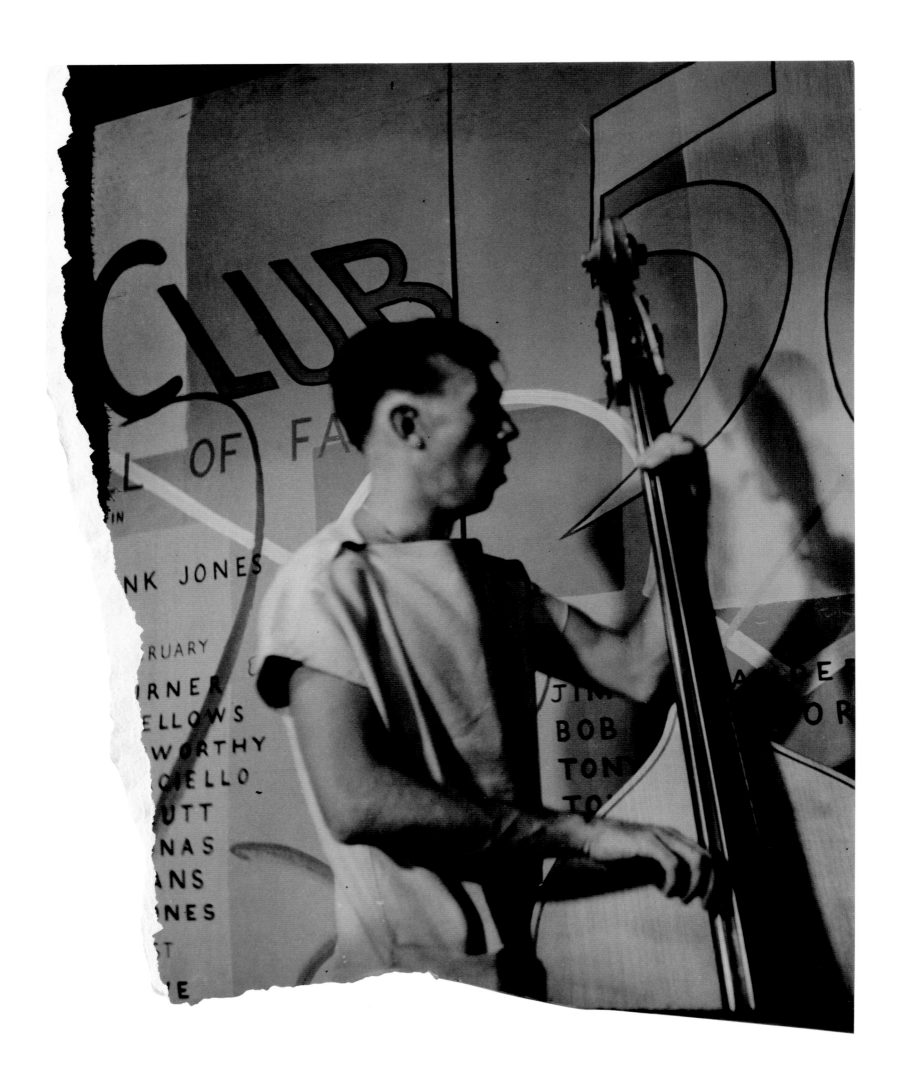

Crazy Jones *1957*

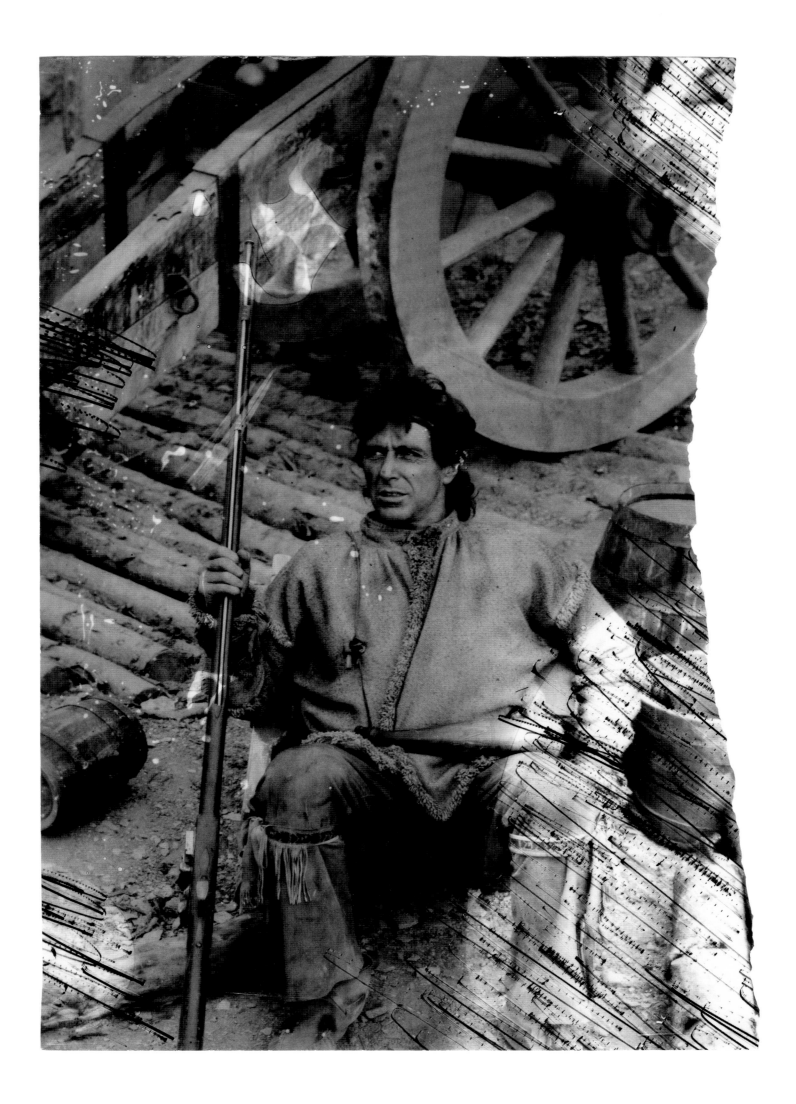

Al Pacino *1985*

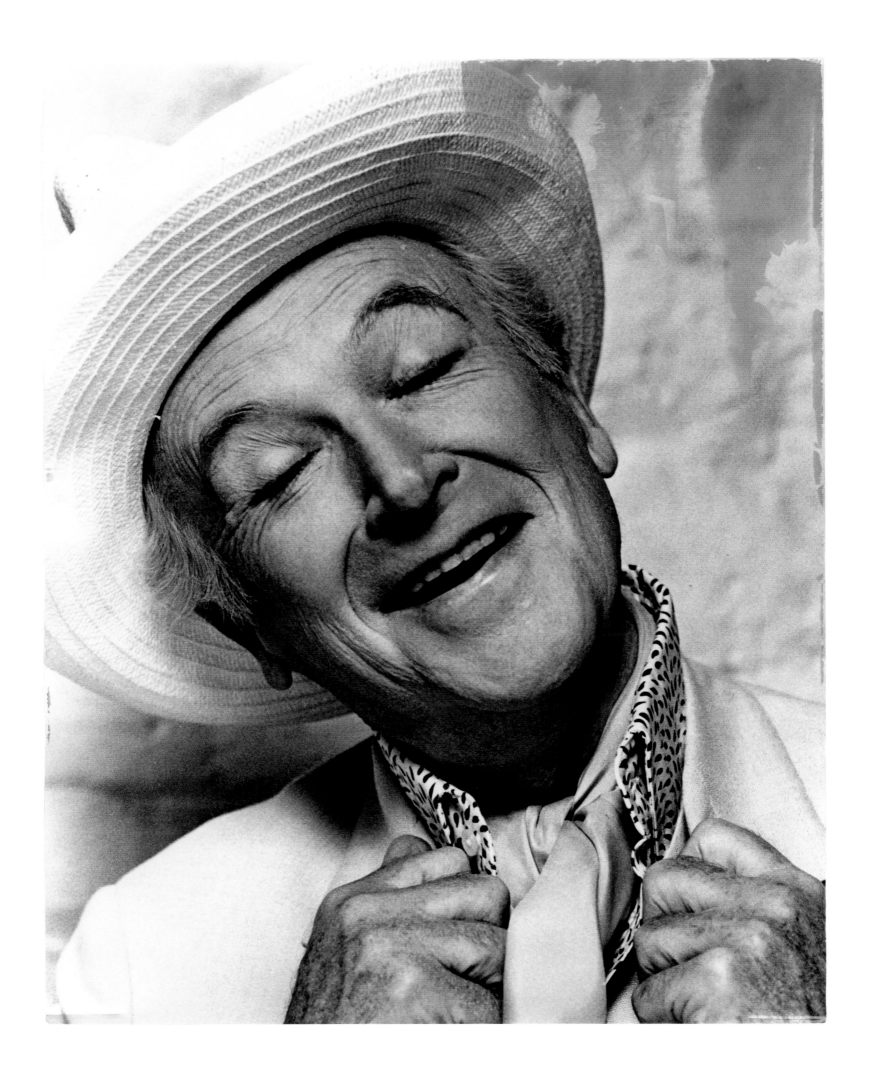

Cecil Beaton *1970*

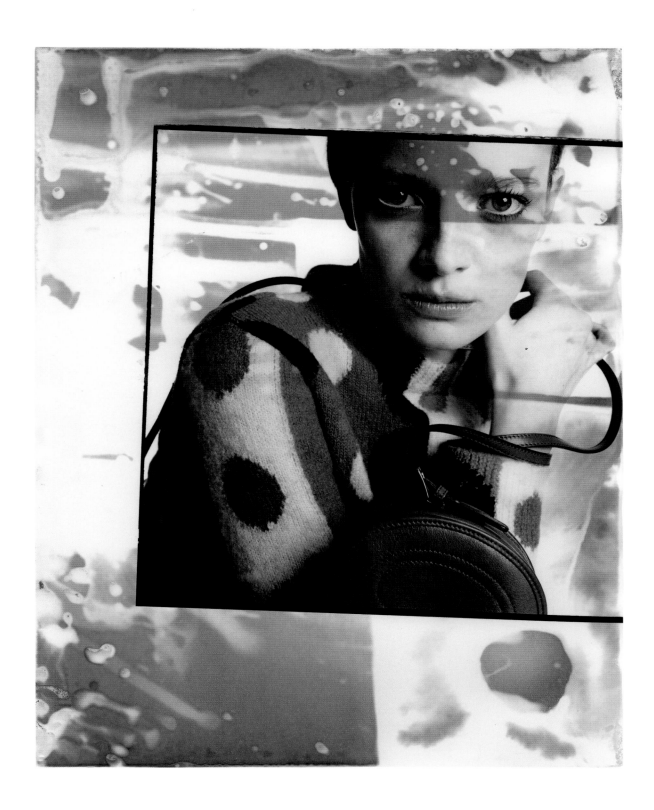

Valentino *2014*

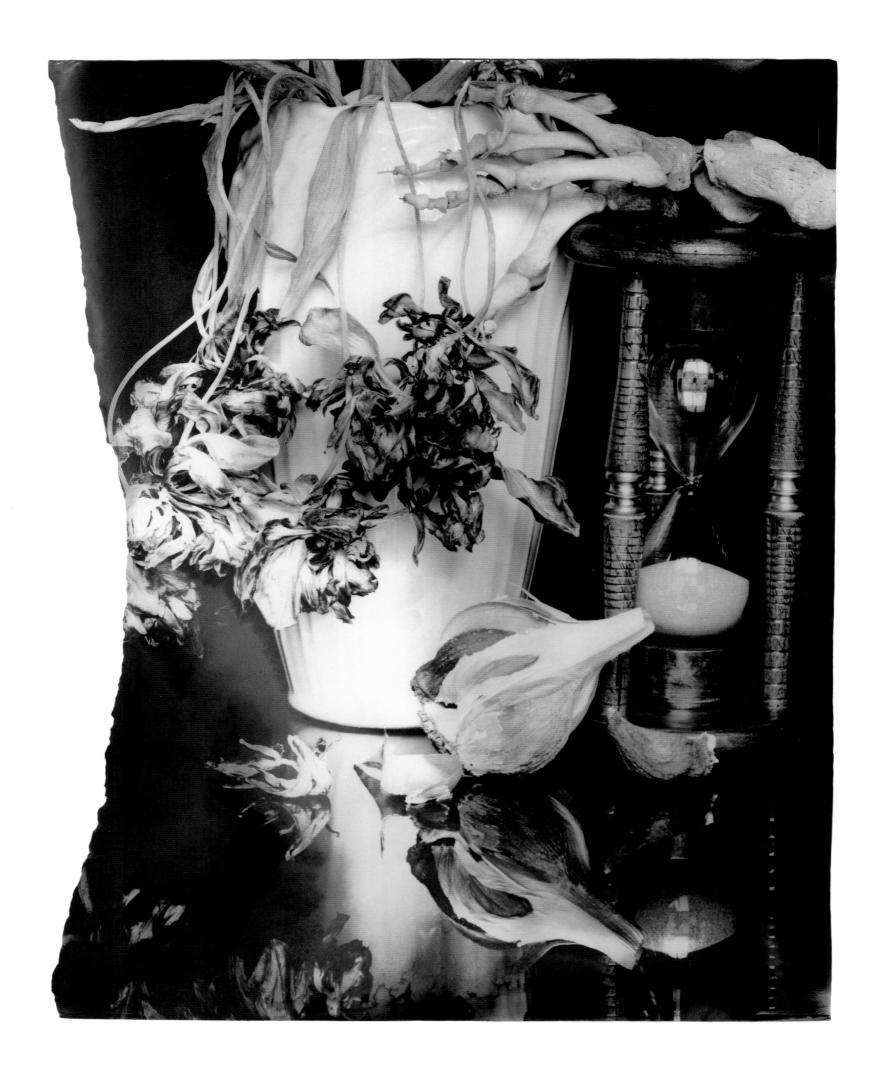

Still Life *2014*

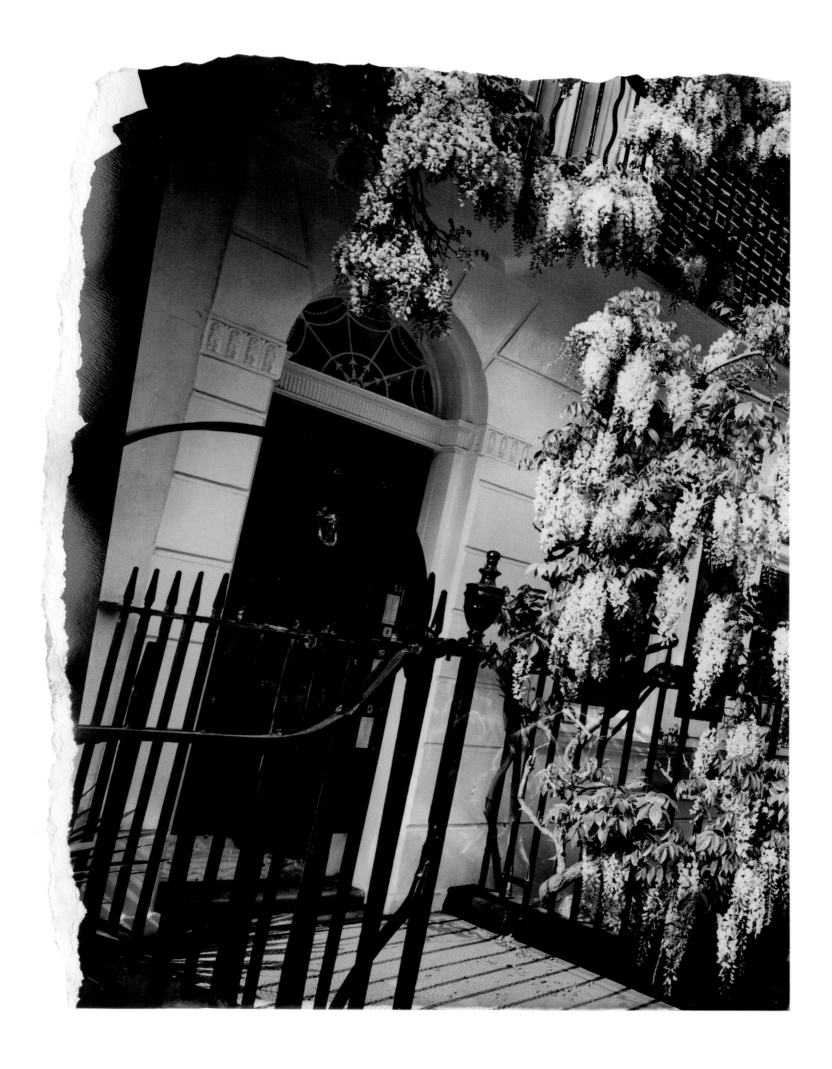

Marylebone *2014*

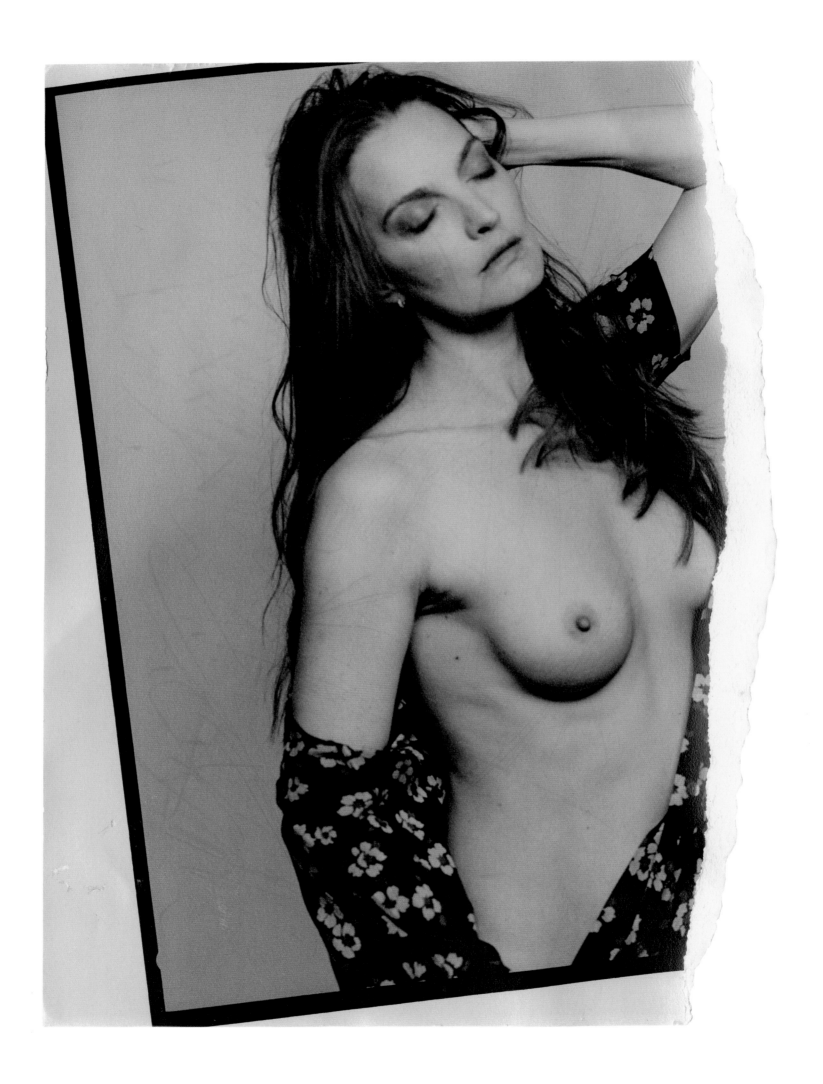

Catherine Bailey *2002*

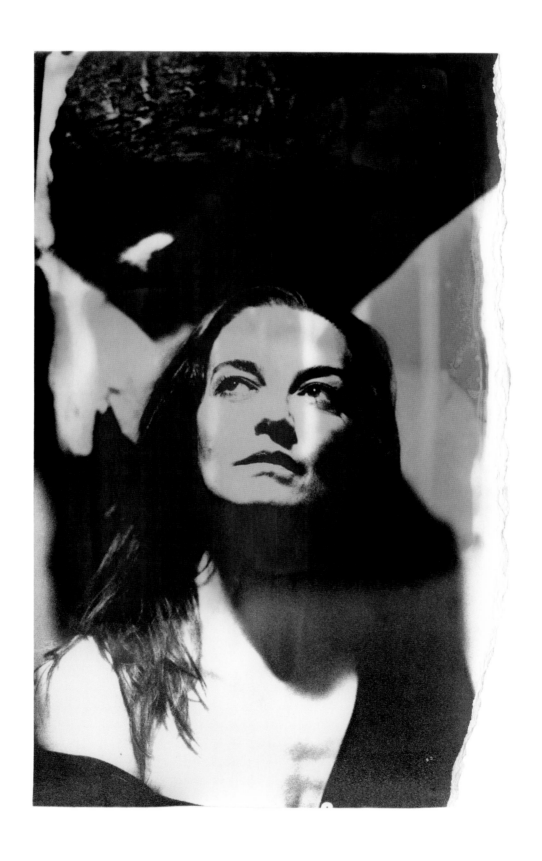

Catherine Bailey *2013*

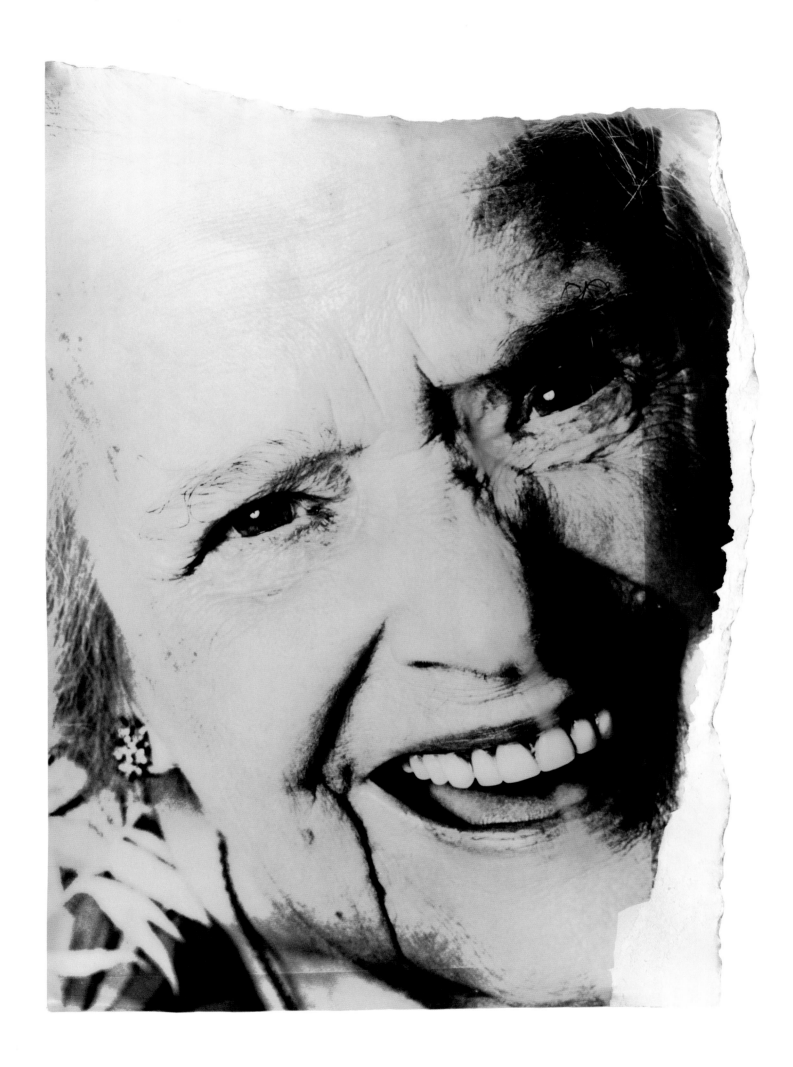

Violet Butler *2014*

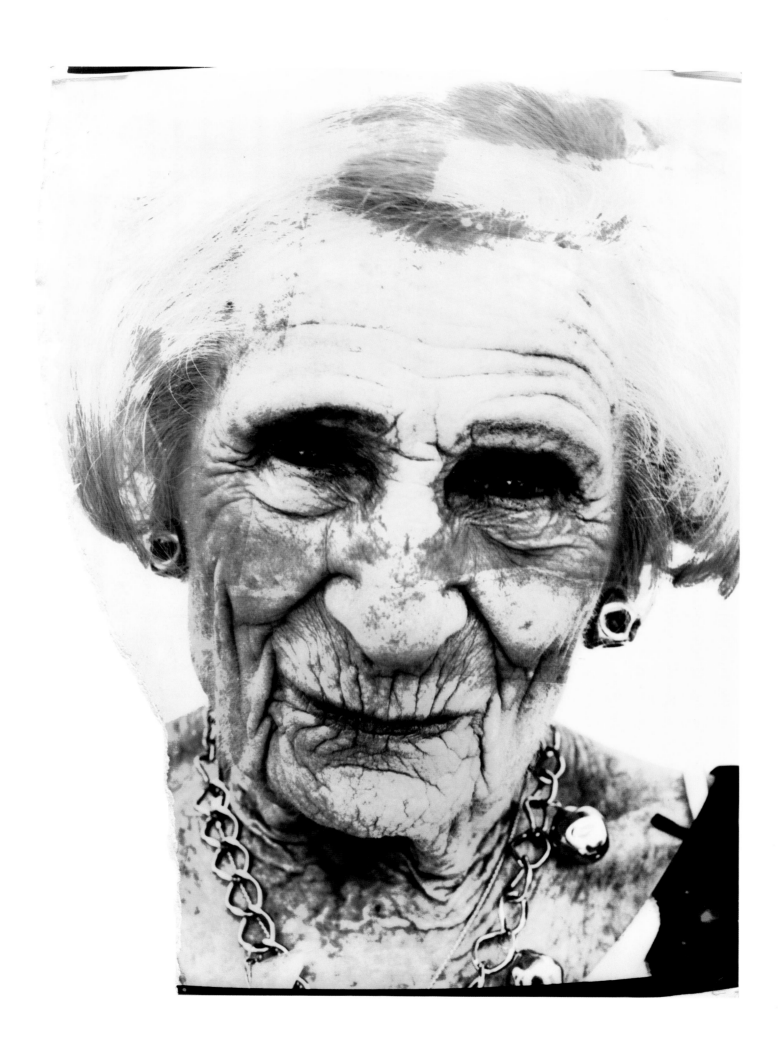

Eileen Symonds *2014*

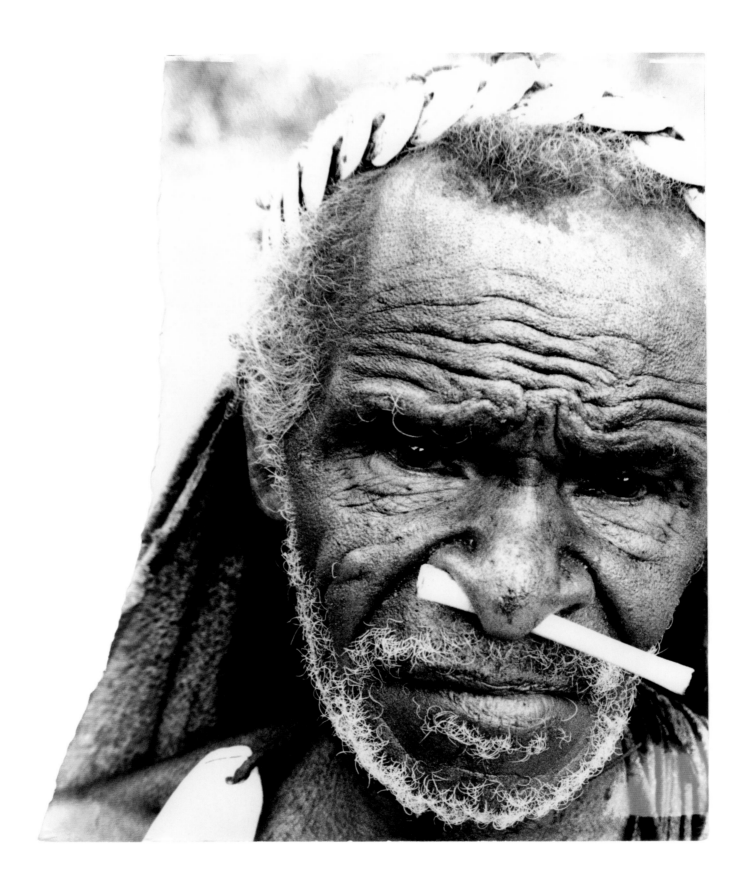

Papua New Guinea *1974*

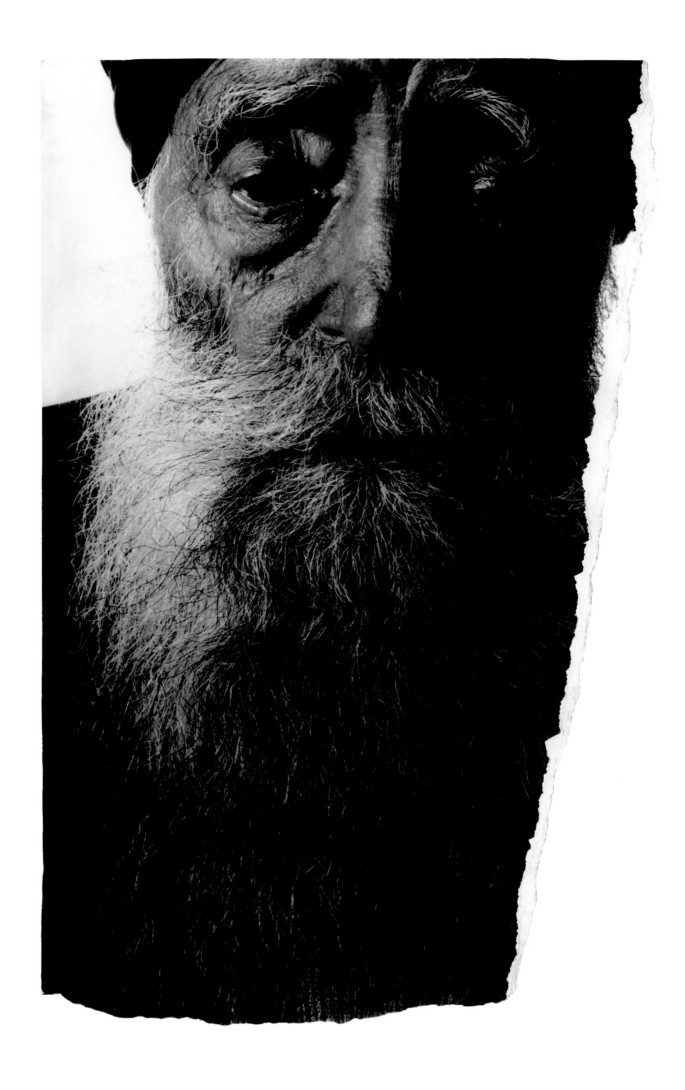

Fauja Singh *2014*

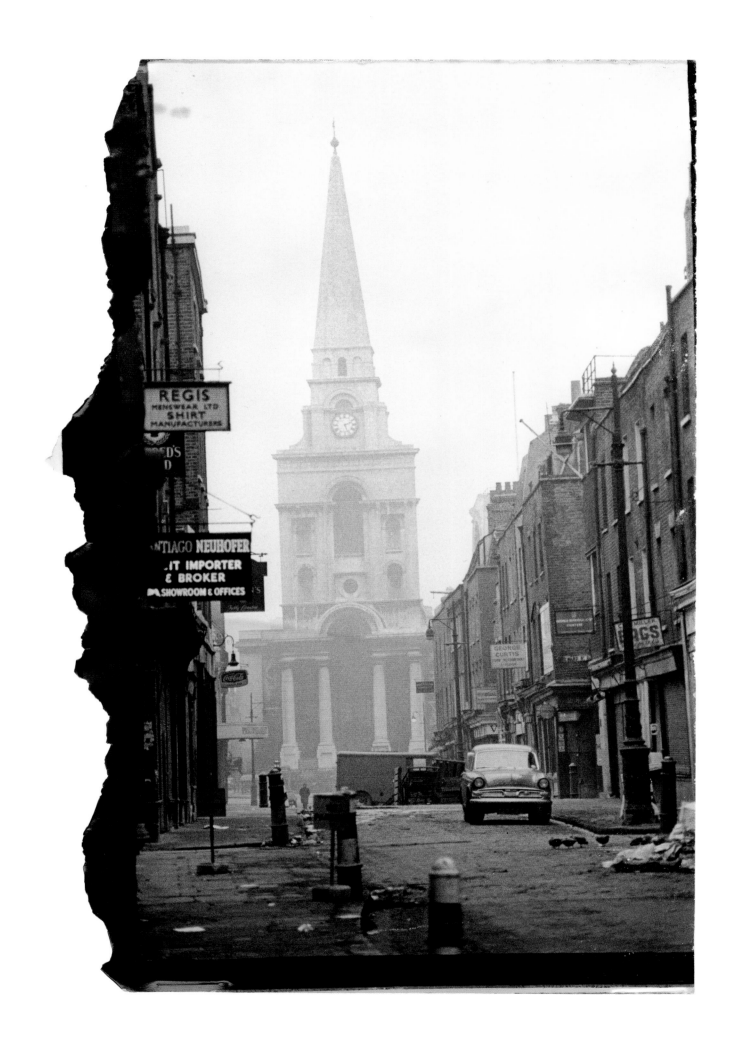

East End *1961*

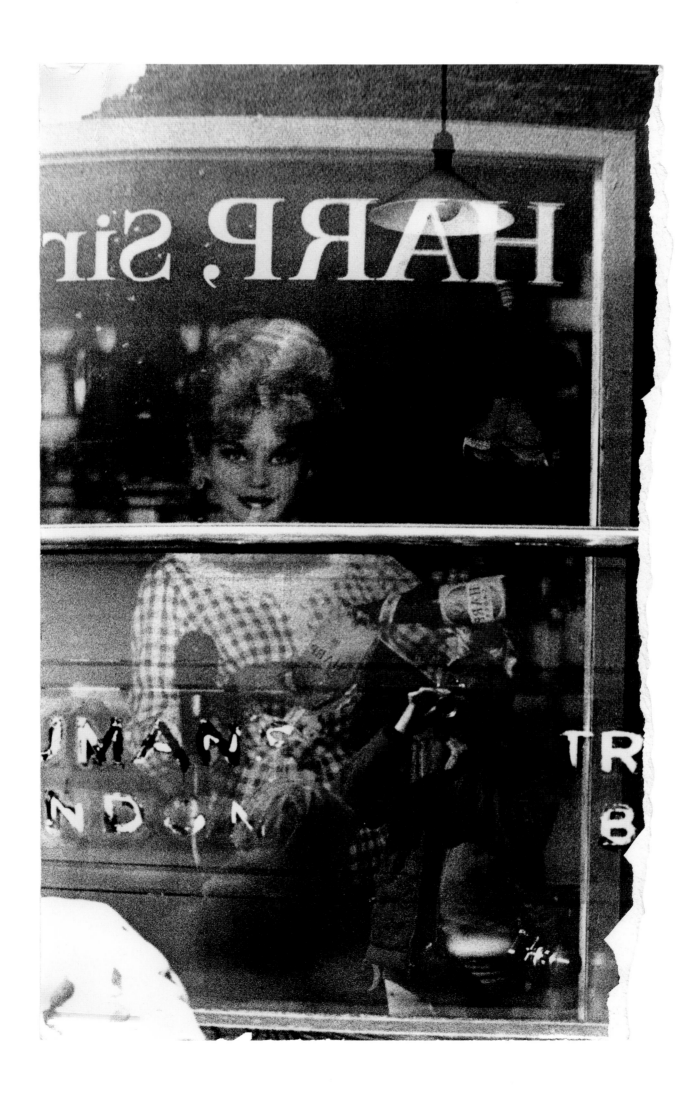

East End *1961*

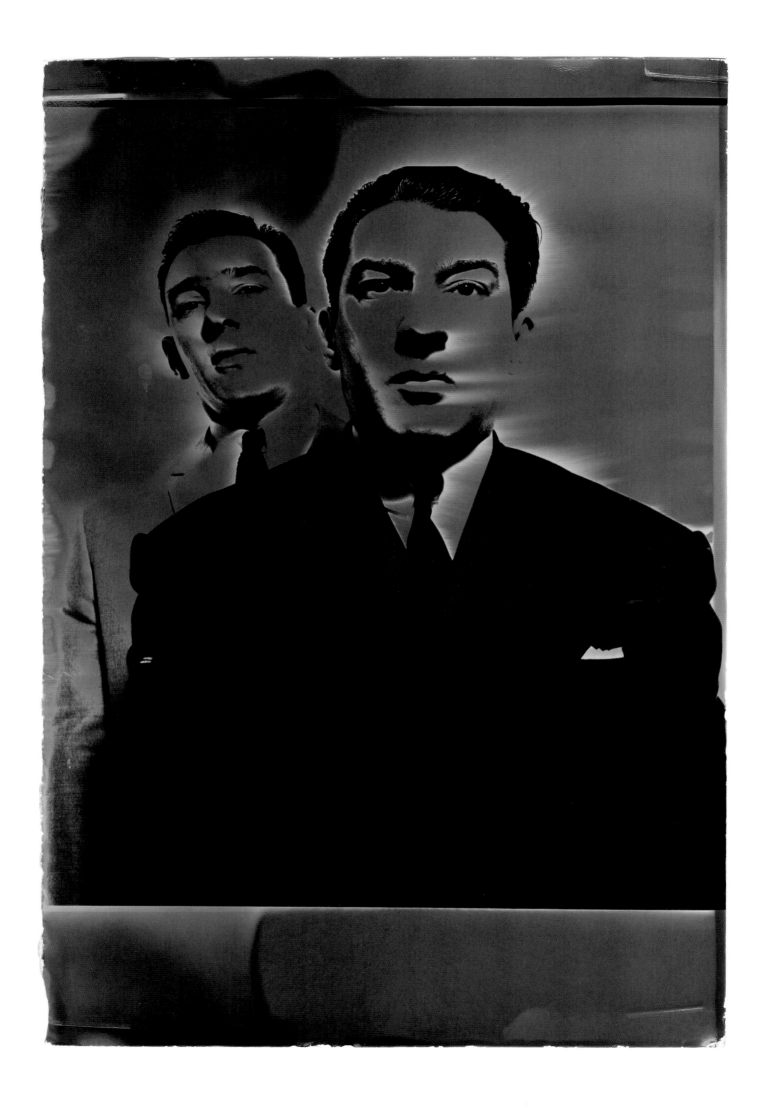

The Kray Twins *1965*

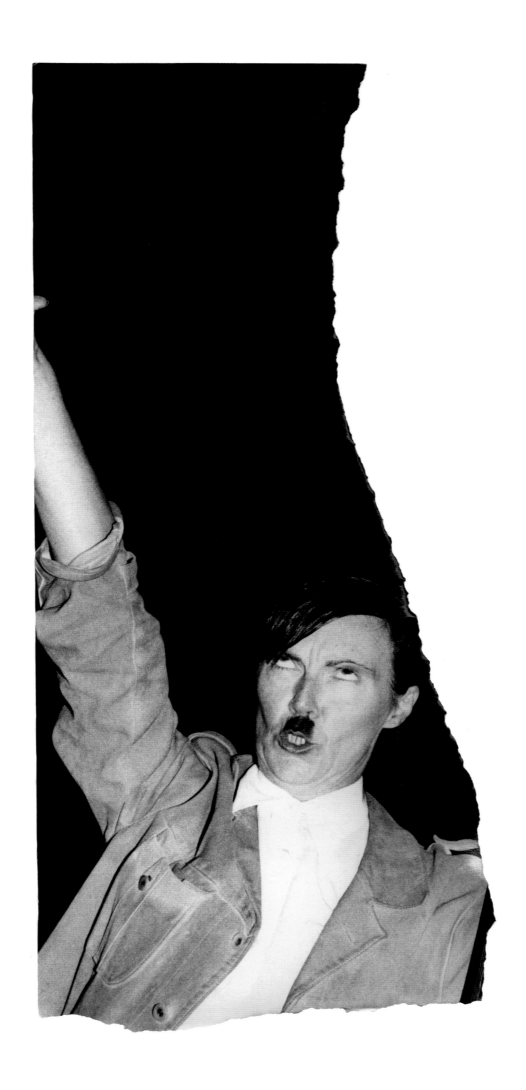

June Newton *1973*

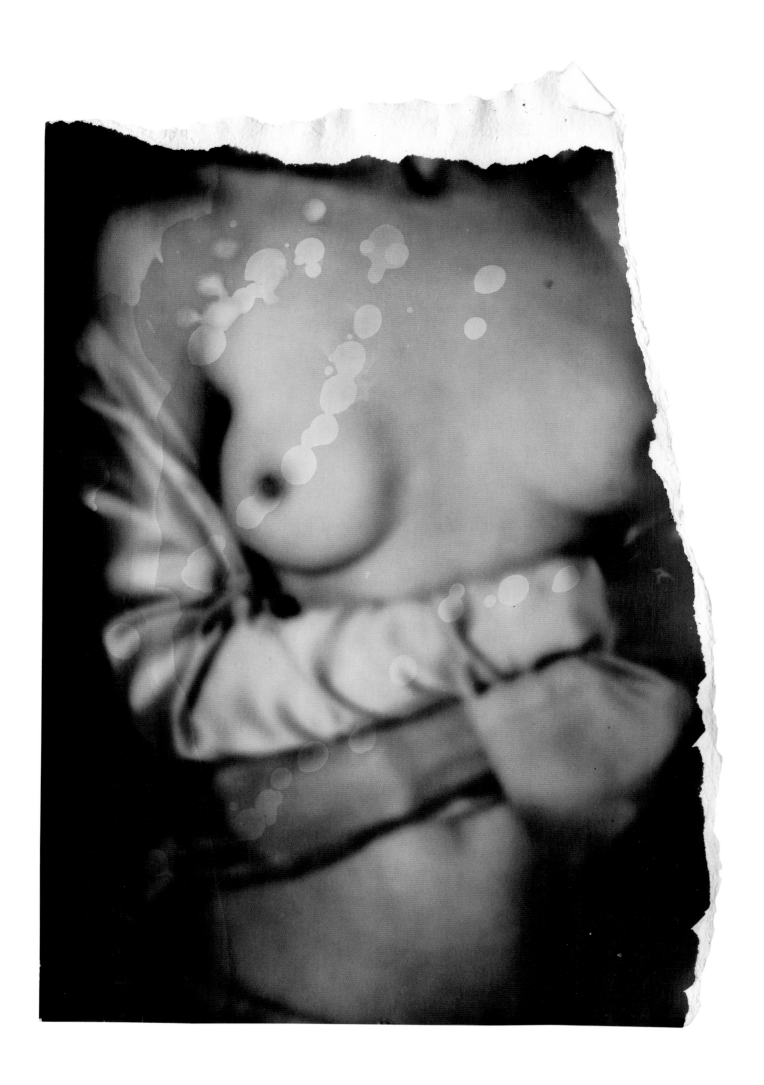

Catherine Bailey *2013*

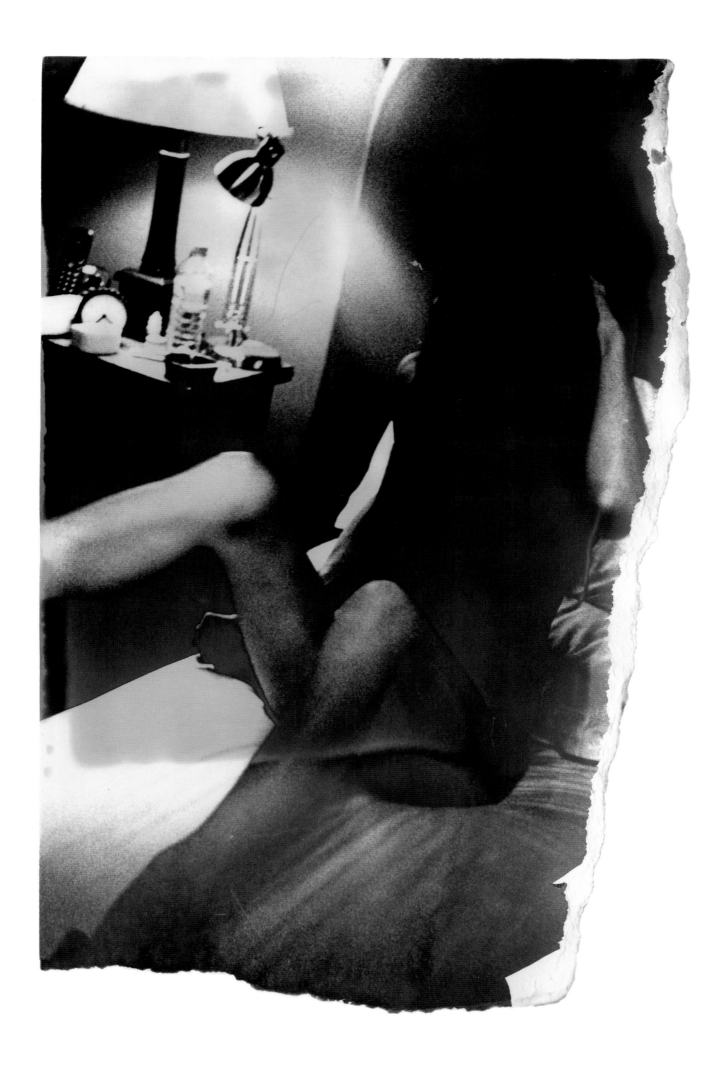

Catherine Bailey *2013*

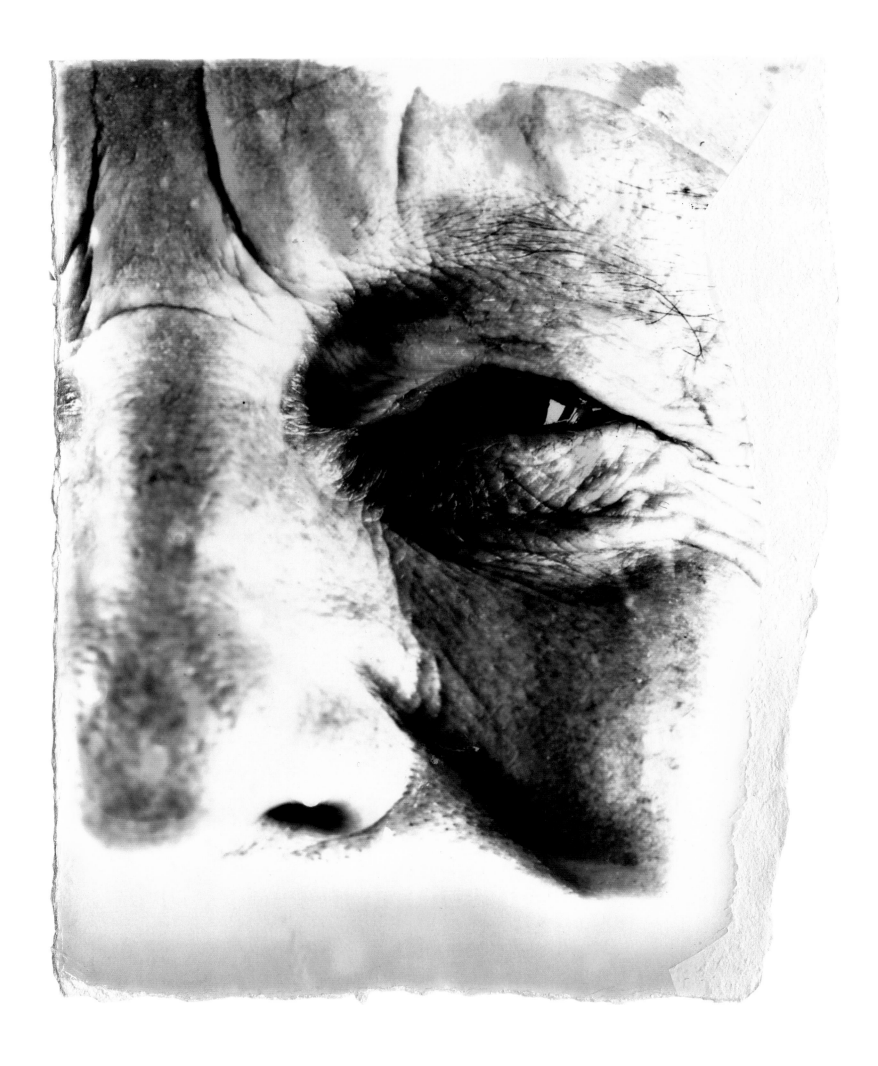

Georg Baselitz *2014*

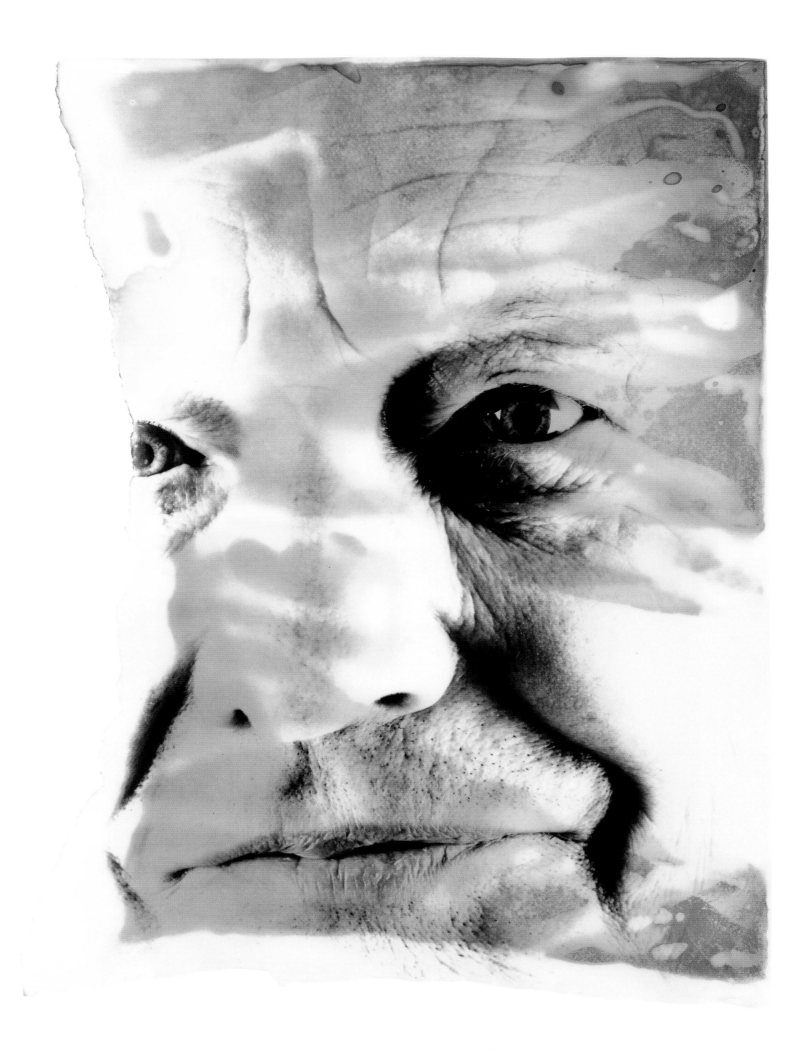

Georg Baselitz *2014*

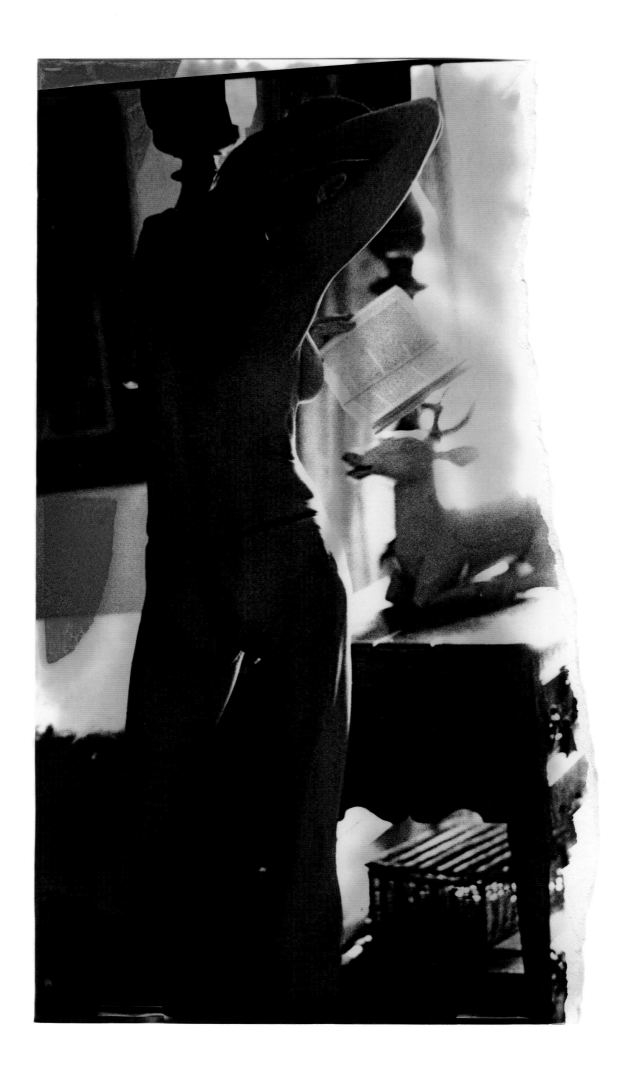

Catherine Bailey 2013

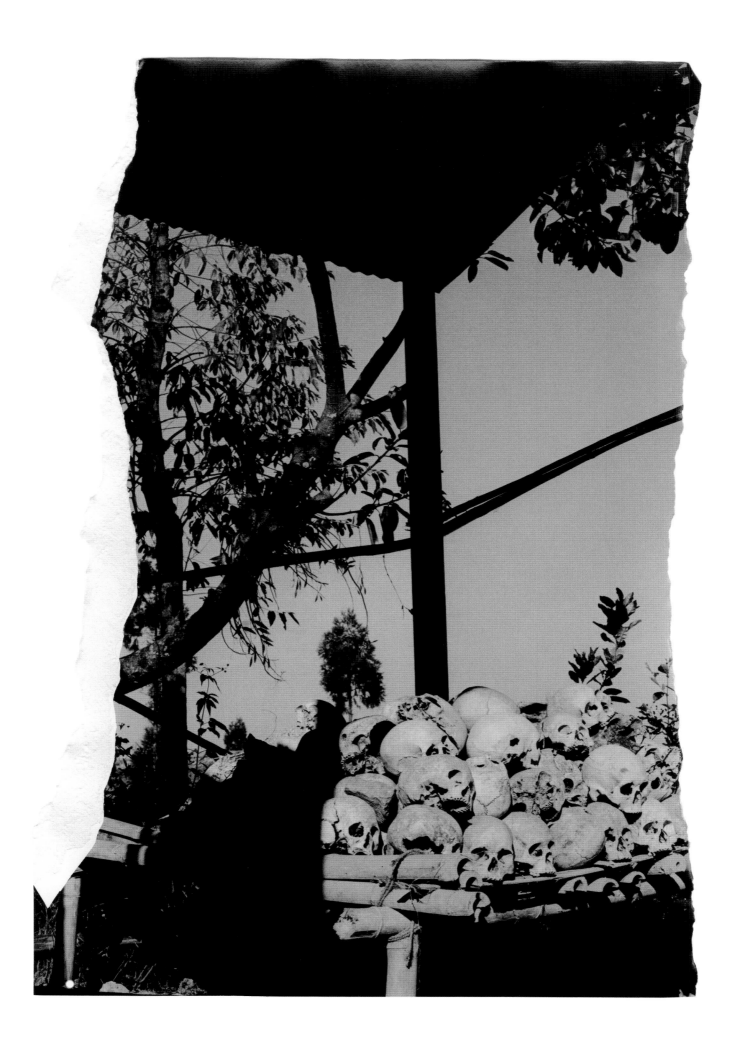

Naga Hills *2012*

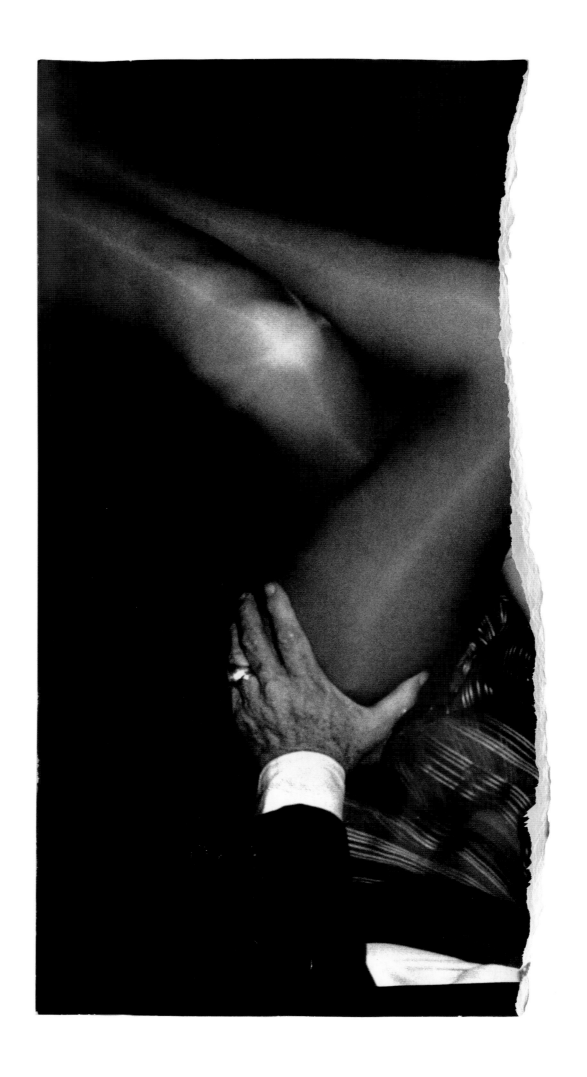

Amanda Lear *1977*

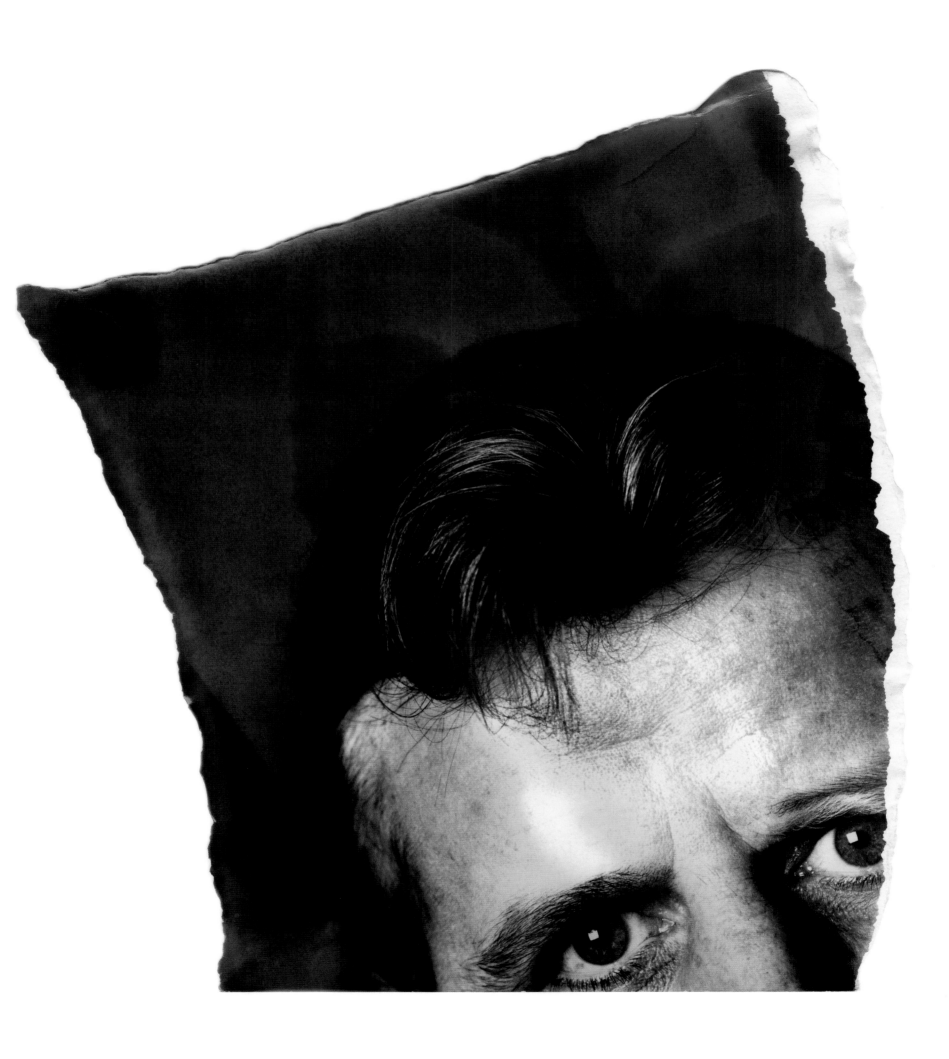

Ringo Starr *1985*

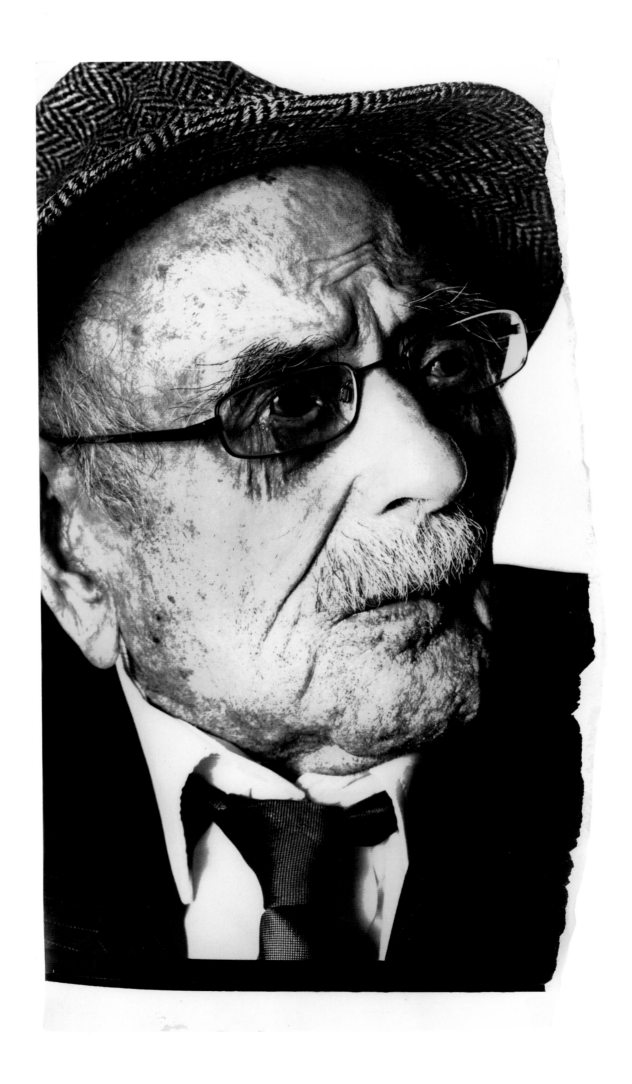

Michael Klanga *2014*

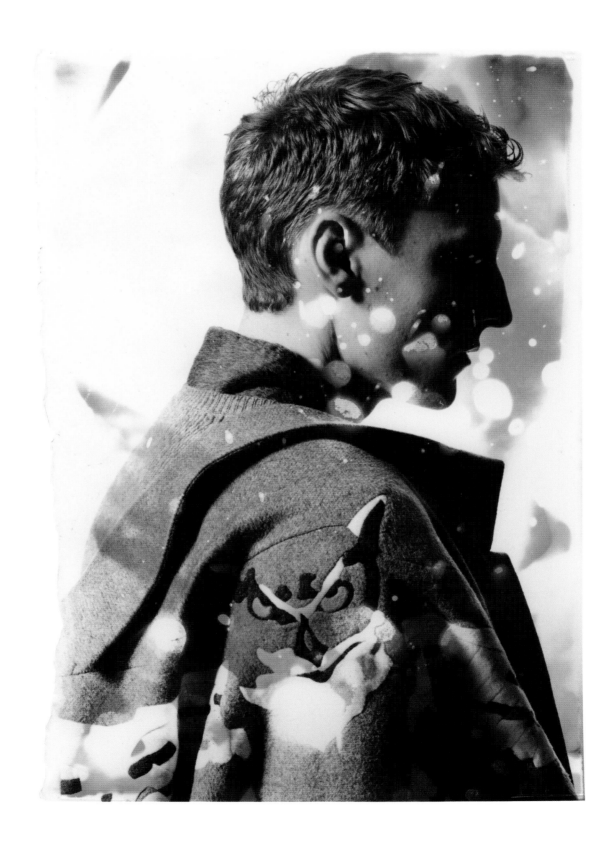

Valentino *2014*

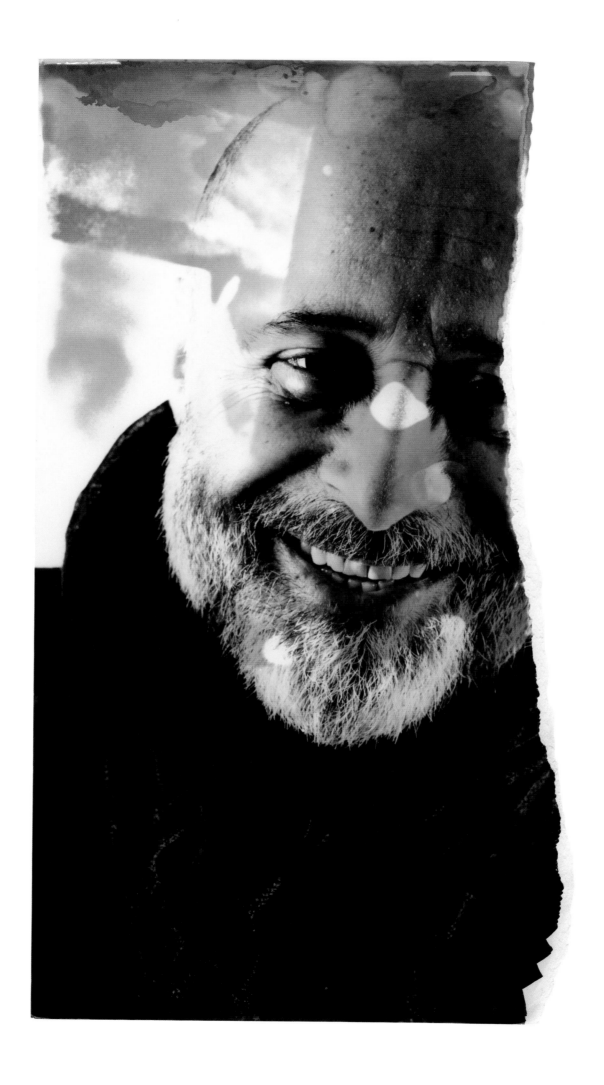

Richard Young *2014*

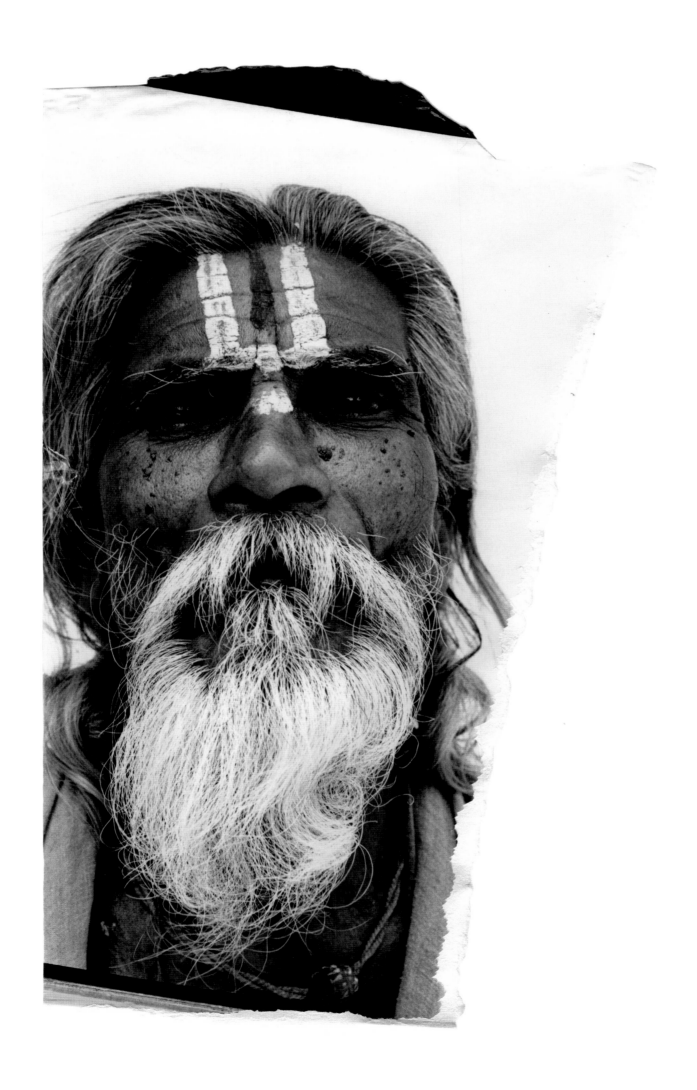

Sardhu, Delhi *2011*

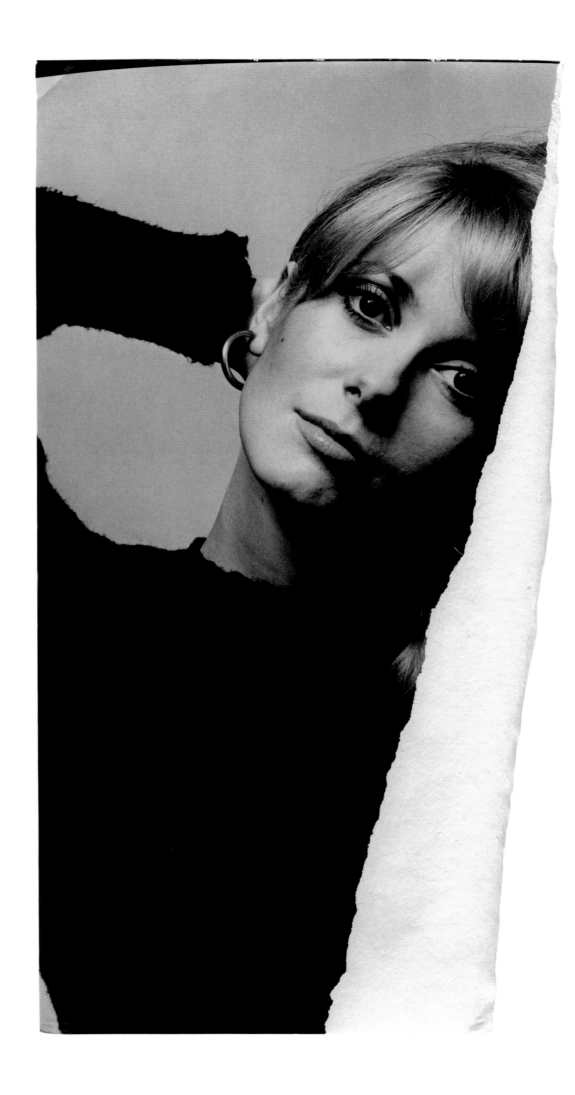

Catherine Deneuve *1966*

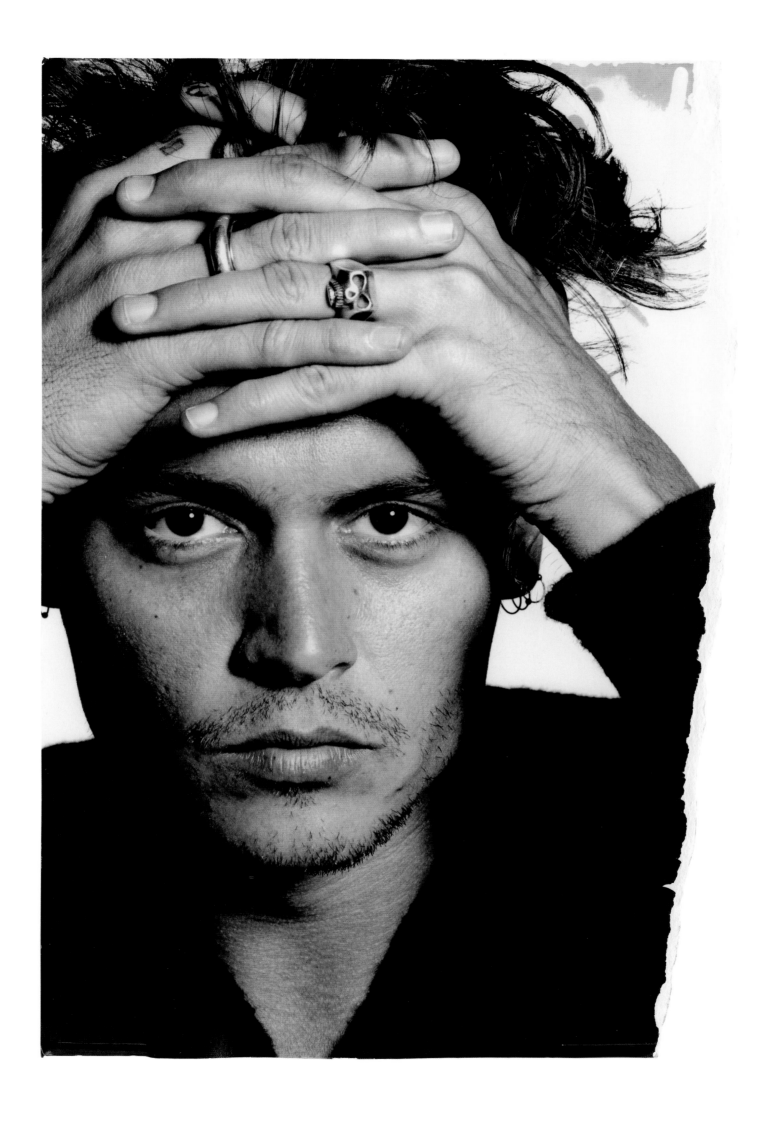

Johnny Depp *1995*

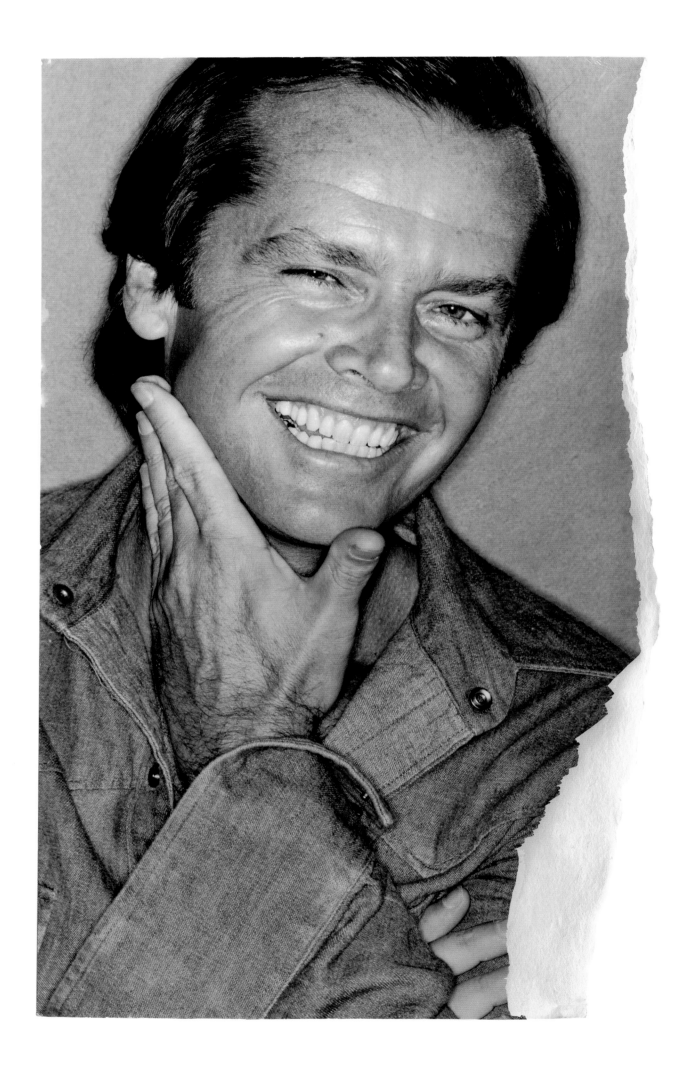

Jack Nicholson *1976*

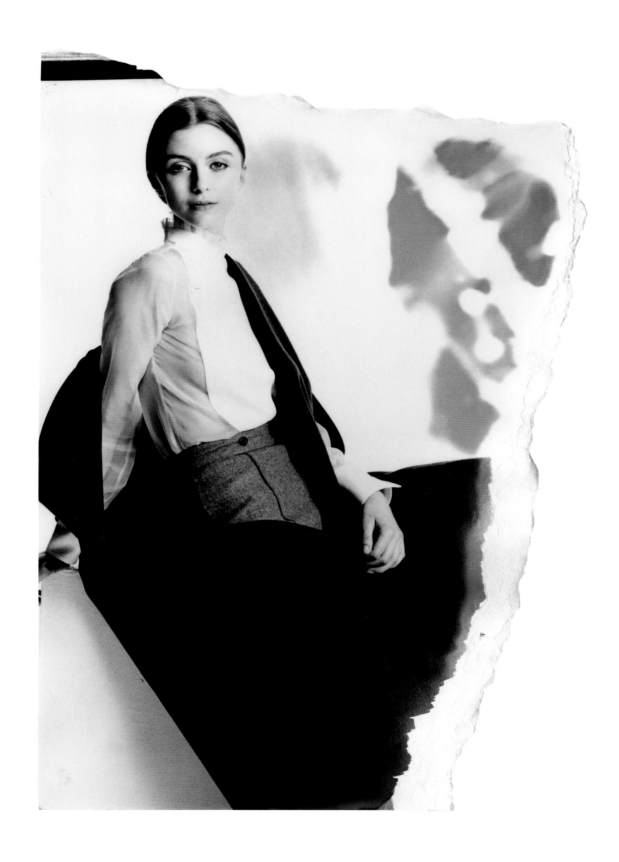

Valentino *2014*

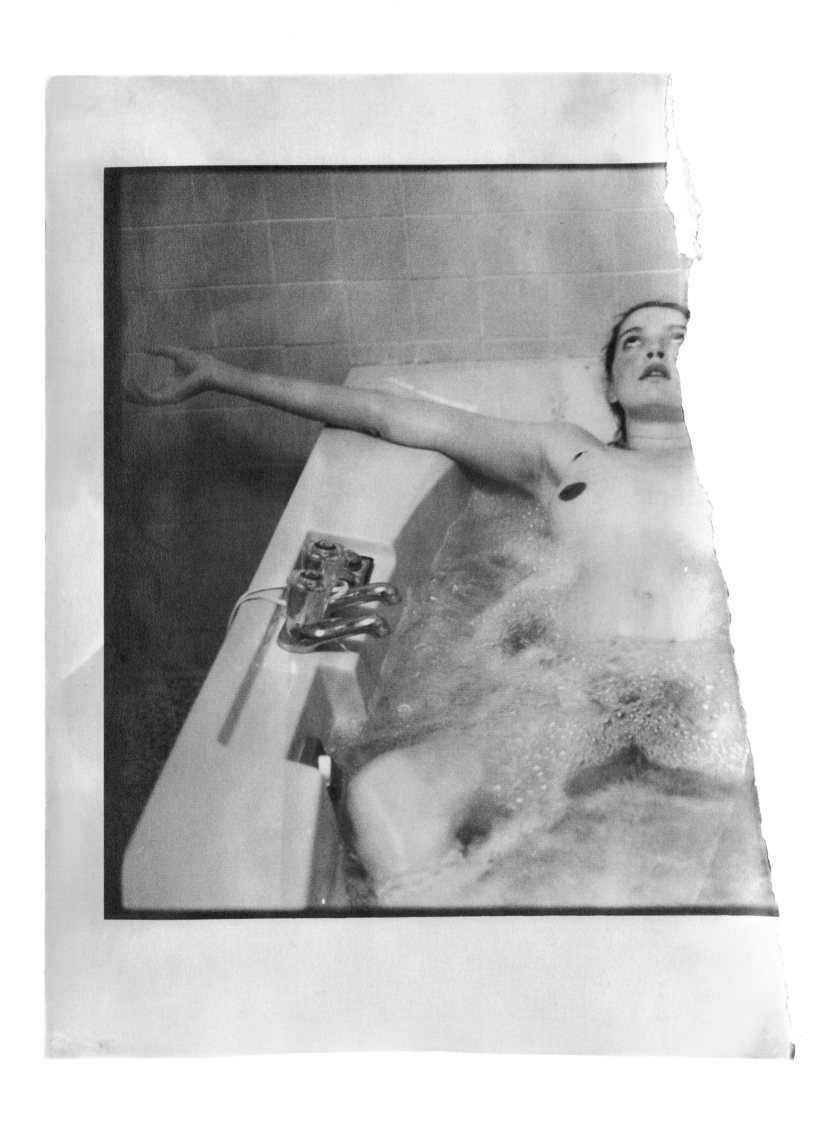

Catherine Bailey *1987*

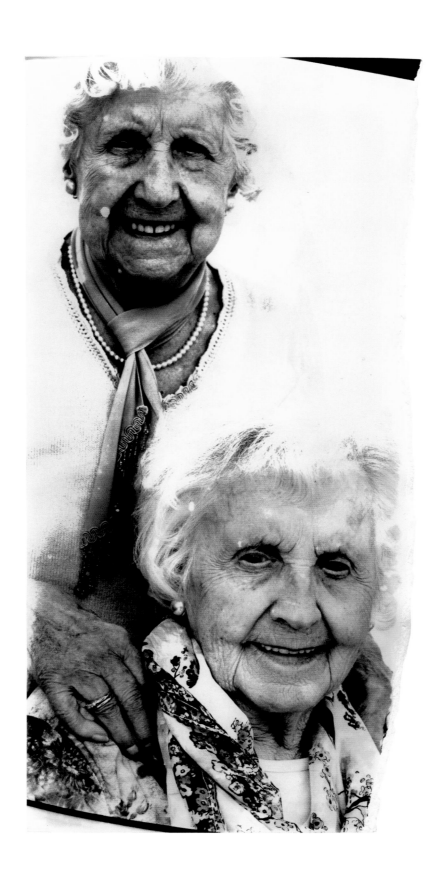

Edith Cashman and Emily Crotty *2014*

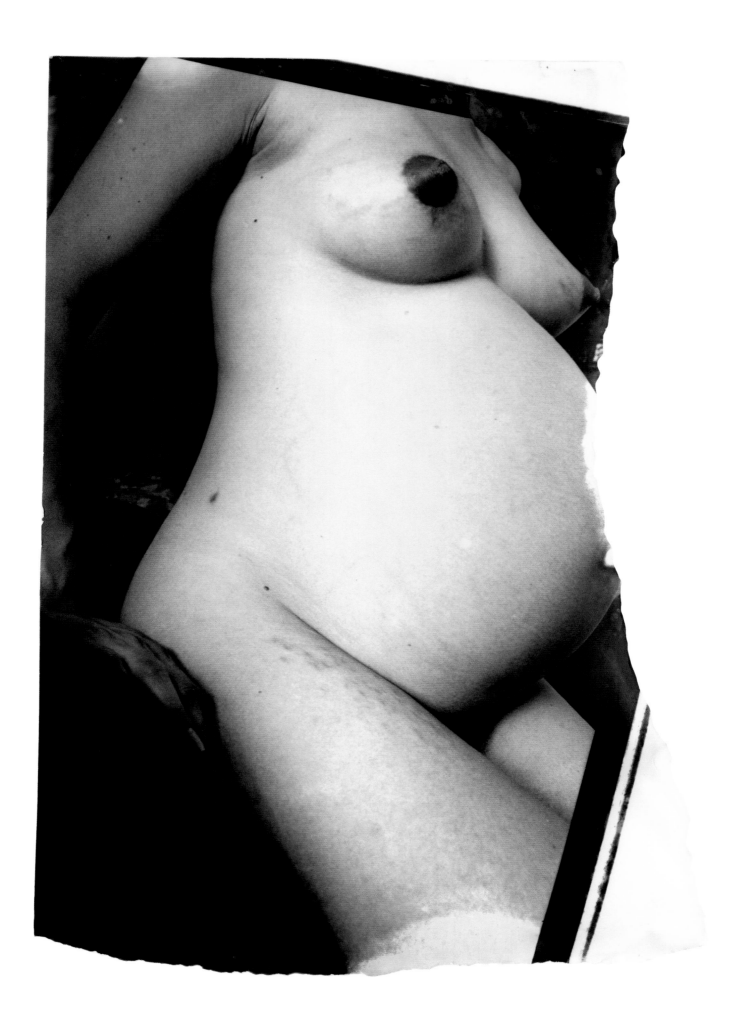

Catherine Bailey *1985*

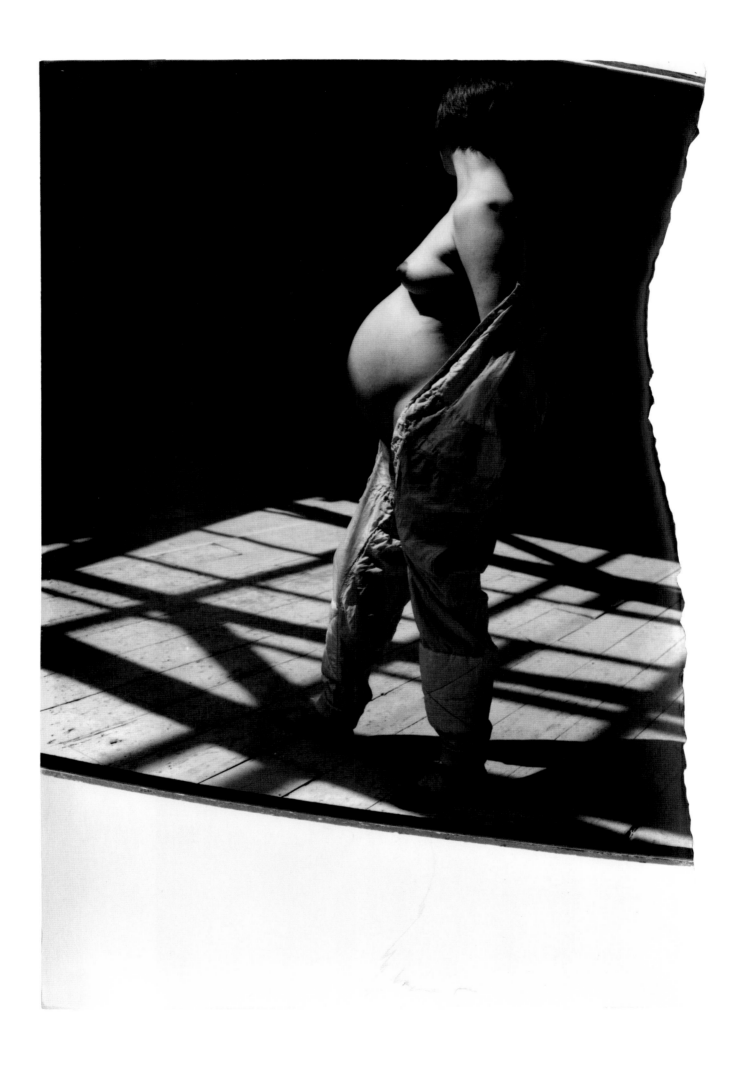

Catherine Bailey *1985*

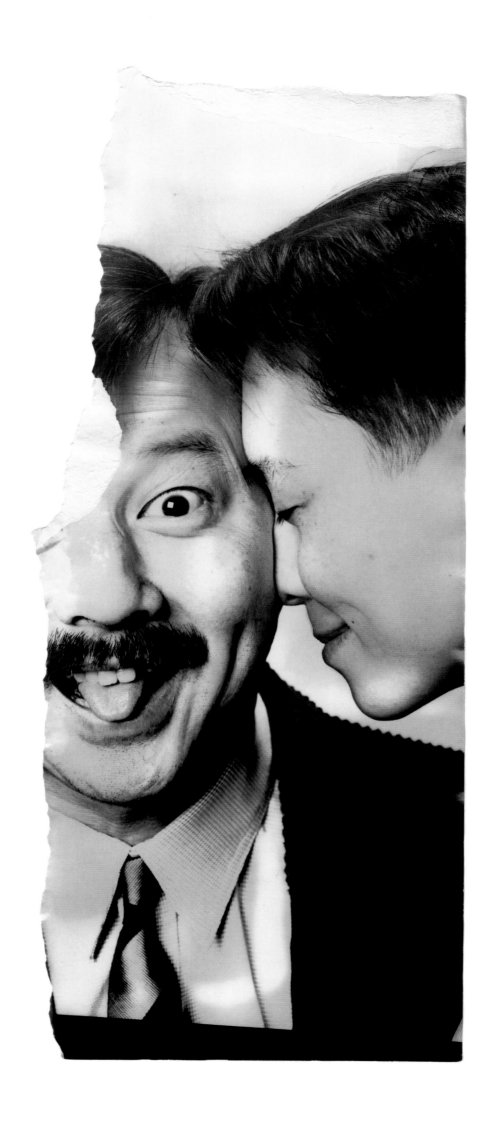

Tina and Michael Chow *1986*

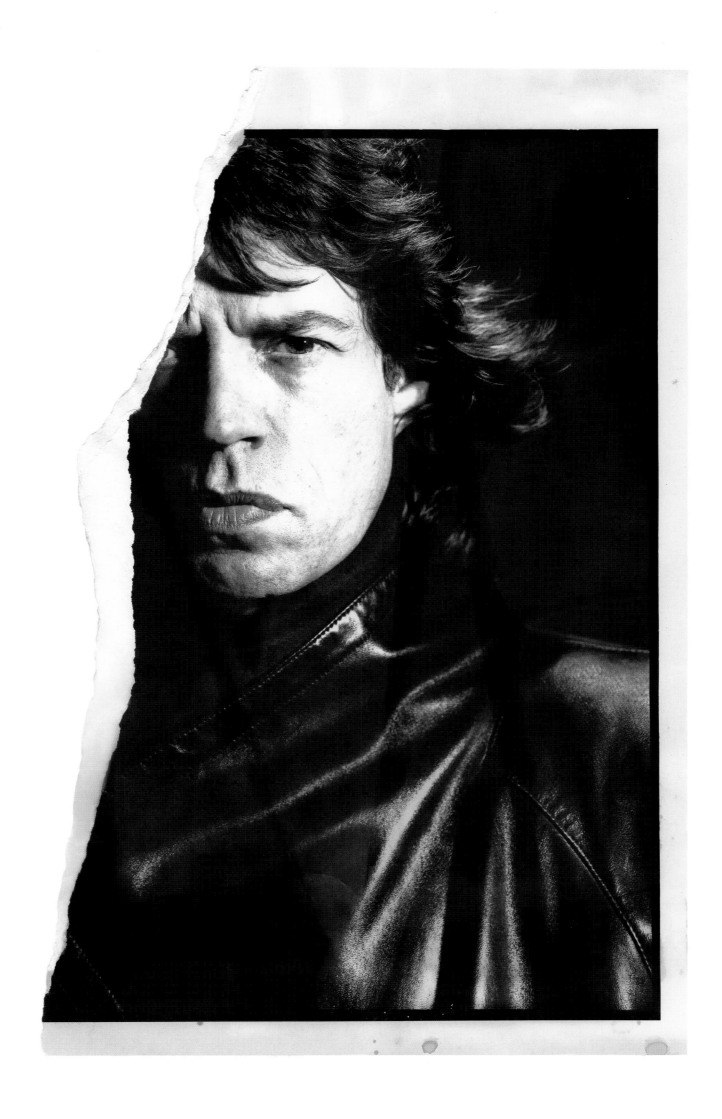

Mick Jagger *1985*

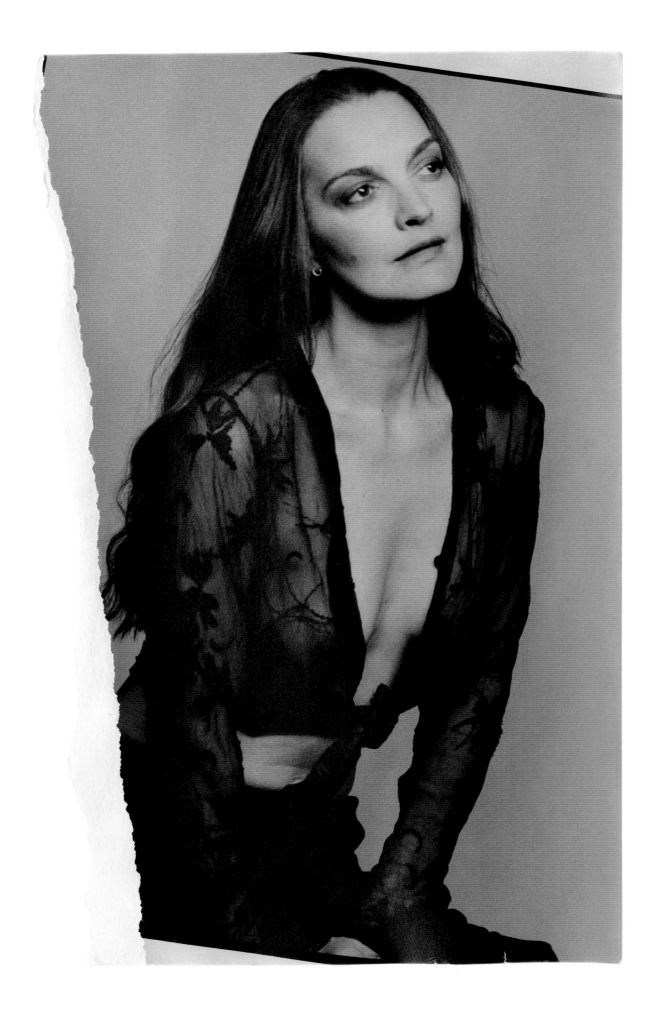

Catherine Bailey *2002*

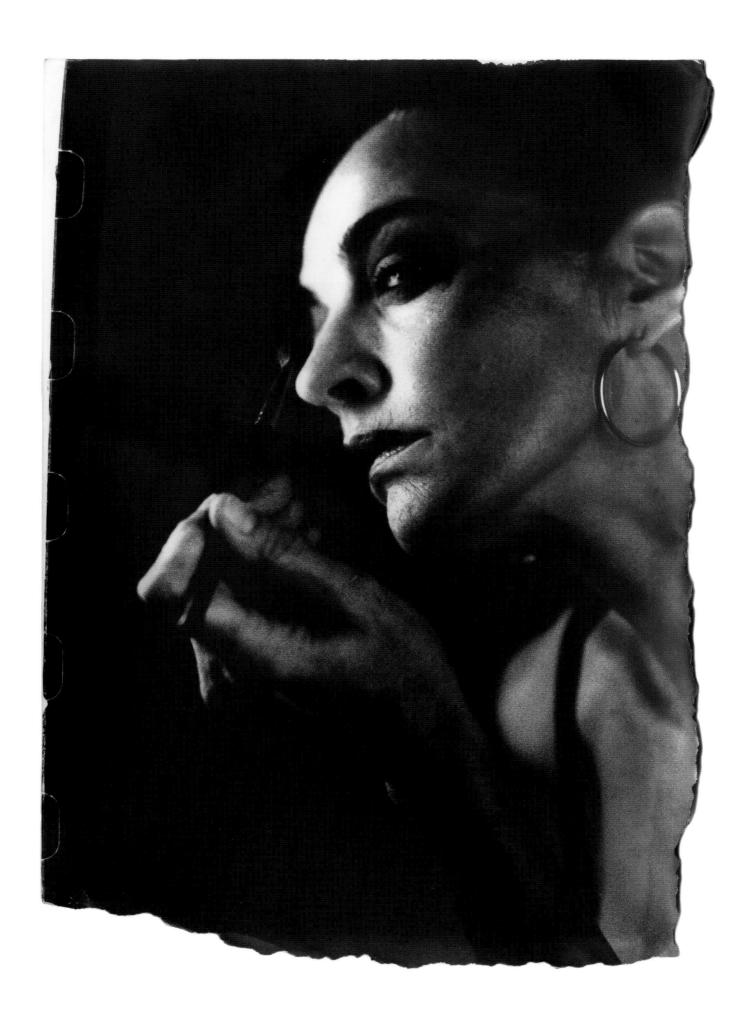

Catherine Bailey 2013

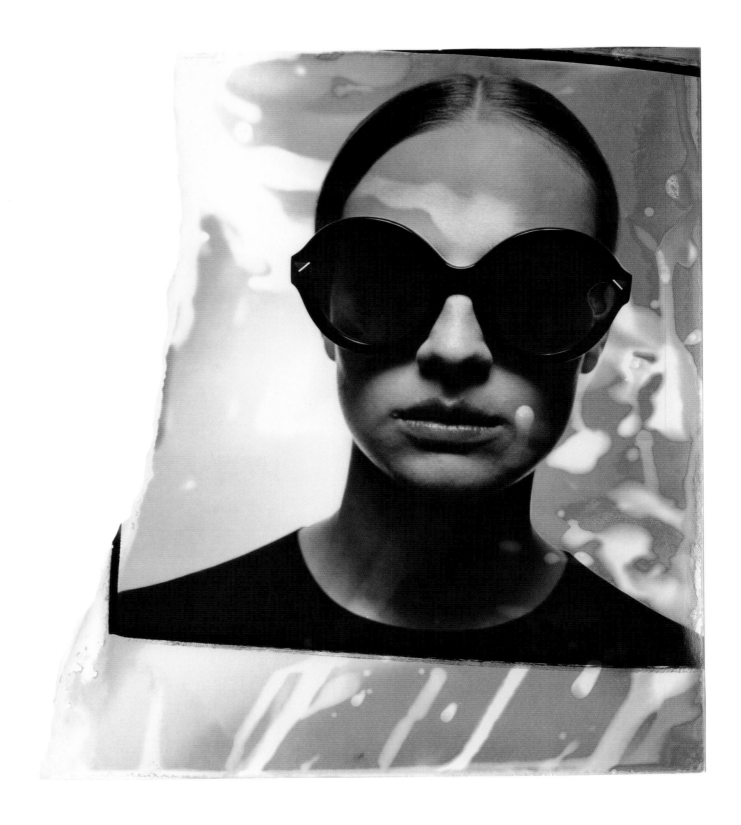

Valentino *2014*

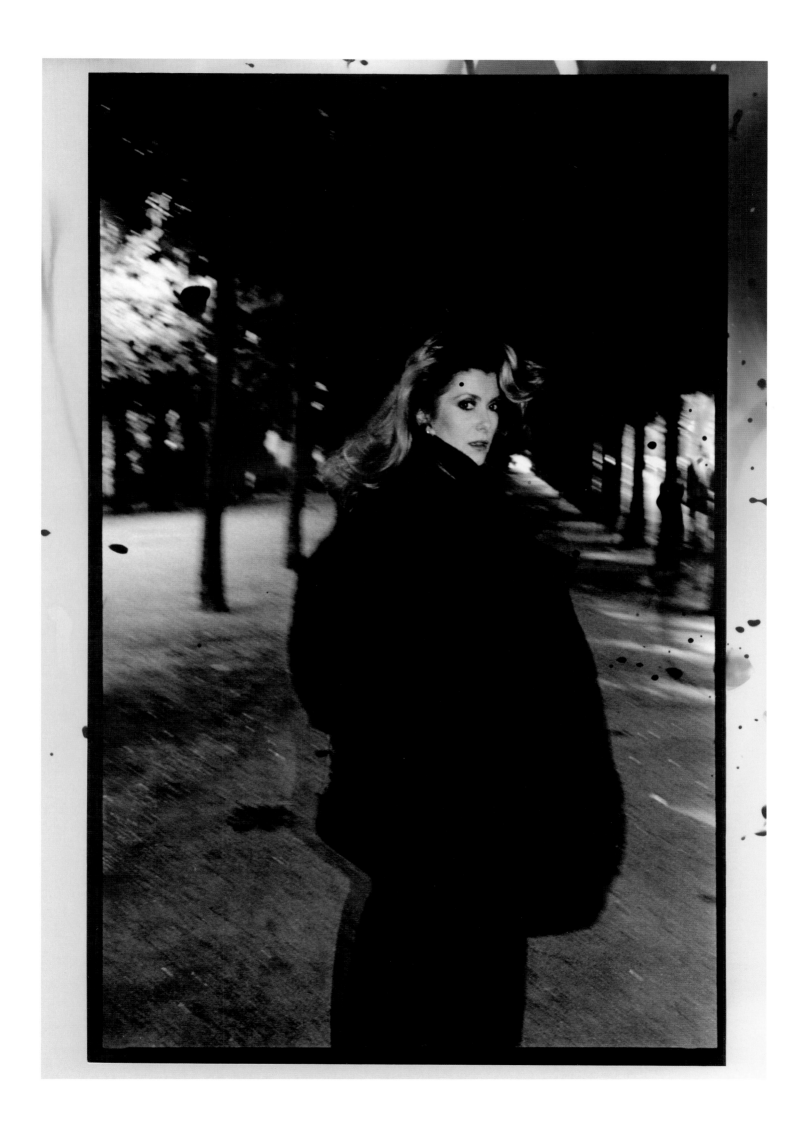

Catherine Deneuve *1983*

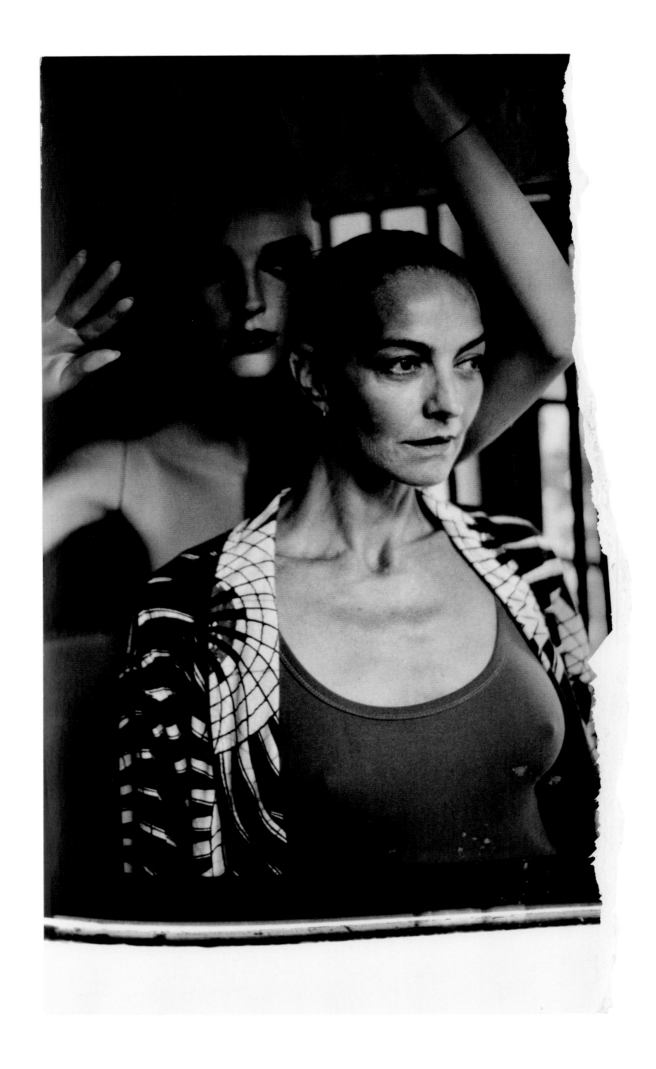

Catherine Bailey *2013*

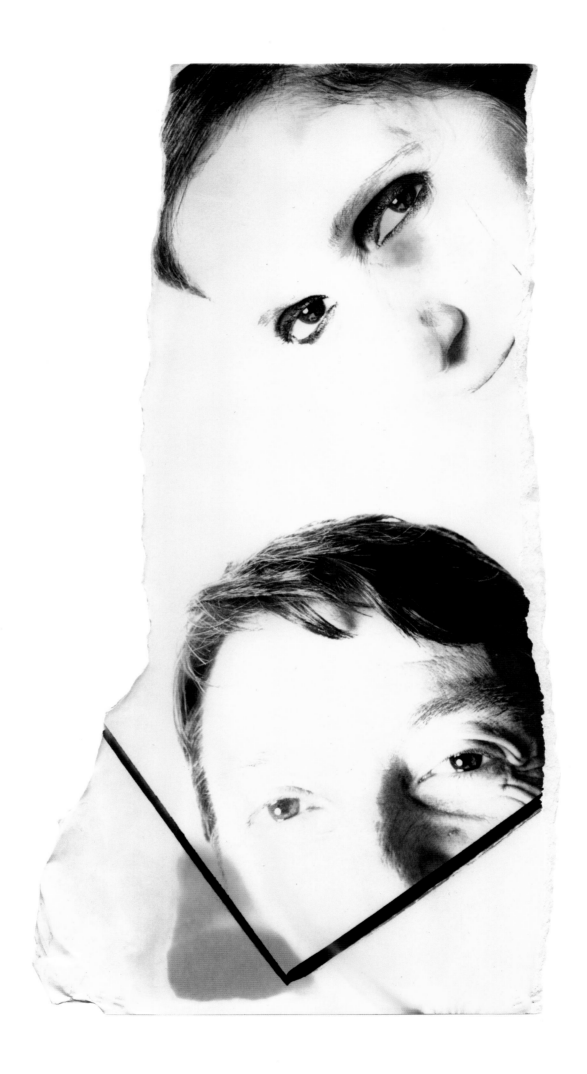

Pierpaolo Piccioli and Maria Grazia Chiuri *2014*

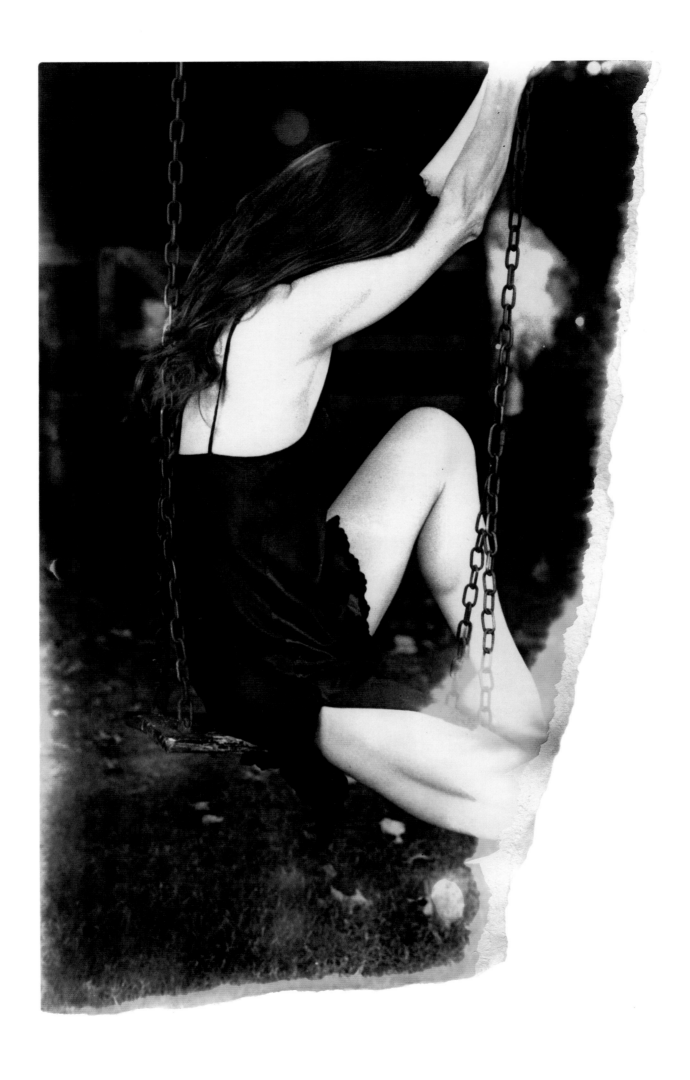

Catherine Bailey *2013*

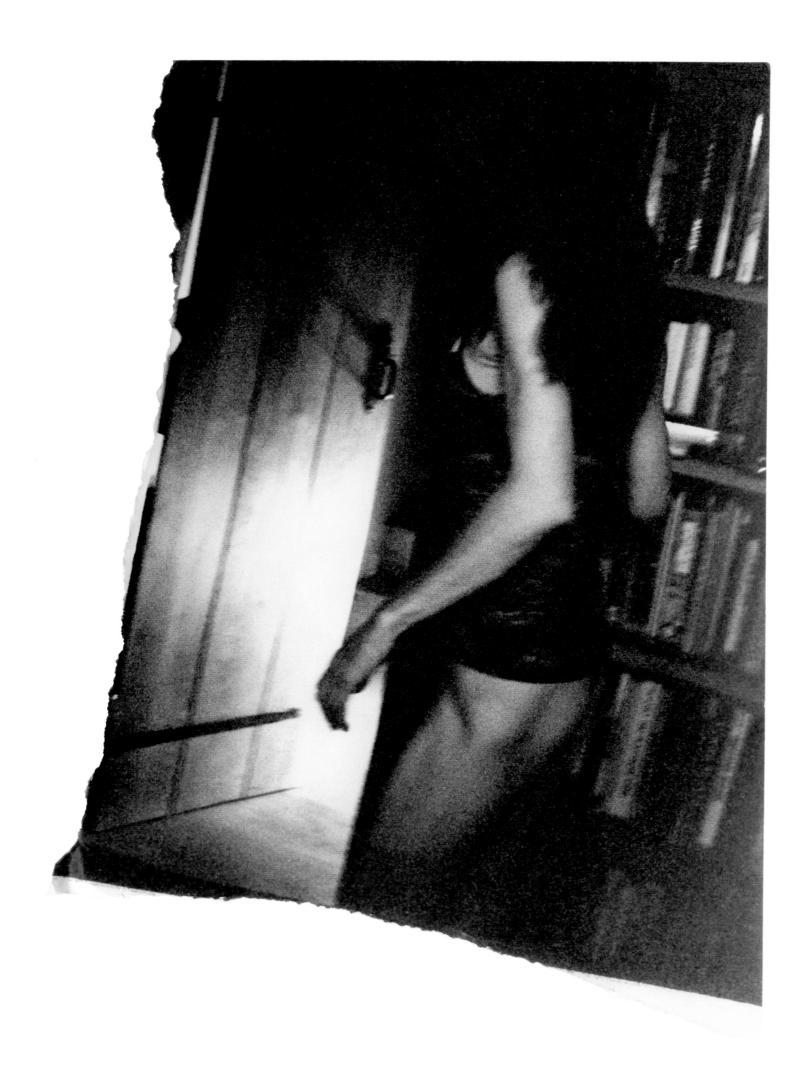

Catherine Bailey *2013*

Tears and Tears

I first started messing about with film at the age of twelve or thirteen. I would shoot sparrows in our backyard with my mum's (Glad's) Box Brownie. I could never get close enough; all I seemed to get were black, blurred dots, all very smudgy. ("On the Smudge" used to take pictures of the holiday-makers on the pier or sea front. The pictures were always smudgy when they came out, hence "On the Smudge".) I would develop the films in the coal cellar where I had spent most of the Blitz. I would fill my mother's cooking bowl with developer which I must have nicked from the so-called "science teacher". I would then unroll the film, hold each end, and run it through the developer up and down. It was the longest ten minutes I've ever spent. The outcome was train lines over my black-dot smudgy sparrows. After five or six more tries I gave up this method and used a local chemists. They did film. No joy however – still just smudgy sparrows. I used to paint all the time too (mostly Disney characters). I never considered photography as art; that did not change until I was sixteen and started to see LP records with fantastic art and great photographs as covers. I owe it to music – Jazz and the Blues, not Classical (we just thought that was for rich people). Music opened up my ears and record covers opened up my eyes to photography.

All of the above is just to explain the background to the tears and my first smudgy flirt with that magic place called a "darkroom". I more or less taught myself to print. Any chance I got, I'd watch a seemingly very old man, who was definitely an old-school printer. He always seemed to have a fag between his lips. He would sometimes burn in the highlights of the print with his lit cigarette, puffing to make it burn brighter, to literally burn in the whites (which in darkroom speak is called "burning in"). It is an image that has always been with me.

The standard way to make test strips is to make it on a grid system, exposing the uncovered part of the grid, making step prints. Ten seconds, thirty seconds and so on, ending up with ten choices of how long the exposure should be. Then you must go through it all again to find what grade of paper you need. Not for me. I would rather guess by looking at the neg, and just tear a strip off the unexposed paper. I would usually have it in the bag after three tears. I'm sure people with years of experience do the same thing. There were many real printers much more skilled than I am. My plea is that I know what I want, and I welcome the accidents.

After a few years, I started to look at the test tears that I'd had lying about for some time, and would re-fix and wash for archival purposes. I realised they were more interesting than I first thought, that they were unique. They were made without any manipulation by me. They remind me of Man Ray and Duchamp's *Dust Breeding*. It's the accidental nature of the universe. I love an artistic accident. If this was possible with printing paper then I could do the same with canvases by being more extreme, leaving painted canvas outside for a year or two. The elements would do the rest. The first year I tried this I lost three, blown away by the Dartmoor wind – probably some farmer used them to block up the windows of his cowshed. At least they got hung somewhere.

That's my story of the tears. Now waiting for the next accident.

David Bailey

Special thanks

Mark Pattenden
Sarah Brimley
Fenton Bailey
Daniel Blau

First edition published in 2015

© 2015 David Bailey for the images
© 2015 the authors for the texts
Book design: David Bailey
Book production: Mark Pattenden, Sarah Brimley, Fenton Bailey
Production and printing: Steidl, Göttingen

Steidl
Düstere Str. 4 / 37073 Göttingen, Germany
Phone +49 551 49 60 60 / Fax +49 551 49 60 649
mail@steidl.de
steidl.de

ISBN 978-3-86930-989-7
Printed in Germany by Steidl

$65.00

LONGWOOD PUBLIC LIBRARY
800 Middle Country Road
Middle Island, NY 11953
(631) 924-6400
longwoodlibrary.org

LIBRARY HOURS

Monday-Friday	9:30 a.m. - 9:00 p.m.
Saturday	9:30 a.m. - 5:00 p.m.
Sunday (Sept-June)	1:00 p.m. - 5:00 p.m.